# DRAWING
# FANTASTIC
# FURRIES

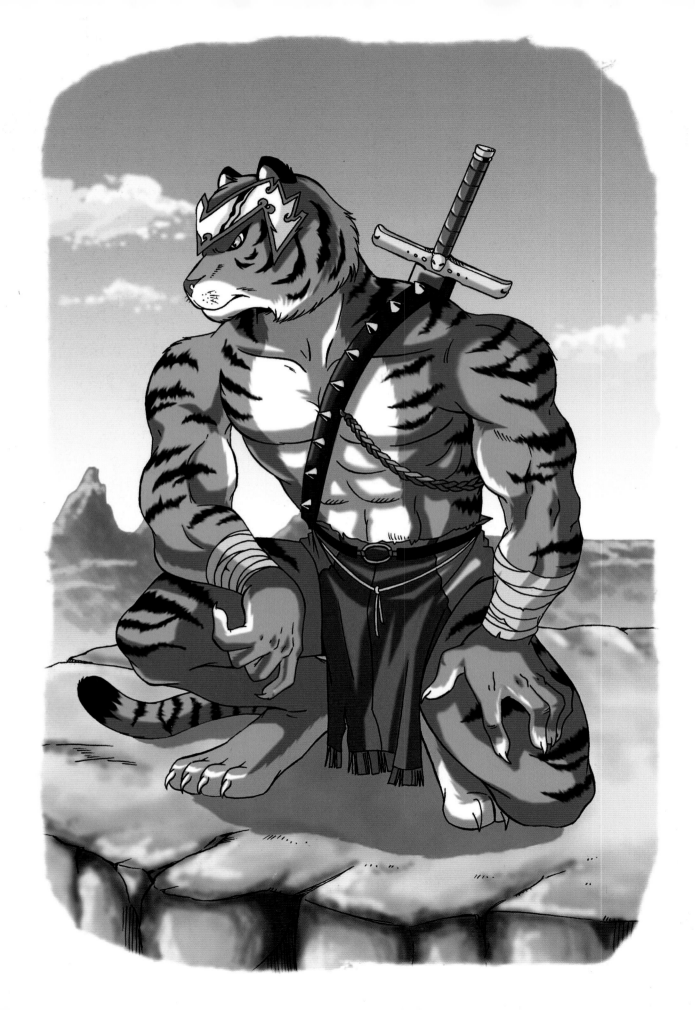

# DRAWING FANTASTIC FURRIES

## The Ultimate Guide to Drawing Anthropomorphic Characters

## Christopher Hart

Watson-Guptill Publications / New York

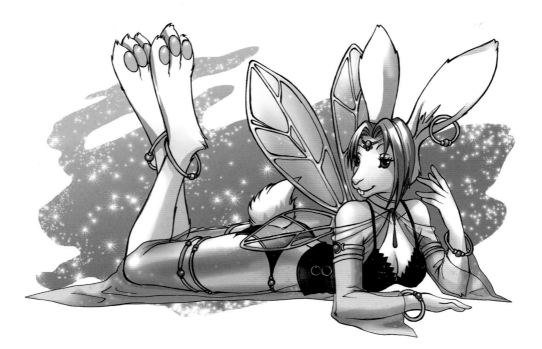

Contributing artists:
Denise Akemi, Paulo Henrique, Tina Francisco,
Christopher Hart, Morgan Long, Roberta Pares

All rights reserved.
Published in the United States by Watson-Guptill
Publications, an imprint of the Crown Publishing Group,
a division of Random House, Inc., New York.
www.crownpublishing.com
www.watsonguptill.com

WATSON-GUPTILL is a registered trademark and
the WG and Horse designs are registered trademarks
of Random House, Inc.

Library of Congress Cataloging-in-Publication Data
Hart, Christopher, 1957–
  Drawing fantastic furries : the ultimate guide to draw-
ing anthropomorphic characters / Christopher Hart.
— 1st ed.
     p. cm.
  Includes index.
  ISBN 978-0-8230-3345-4 (pbk.)
  1. Fantasy in art. 2.  Anthropomorphism in art. 3.
Drawing—Technique.  I. Title. II. Title: Ultimate guide
to drawing anthropomorphic characters.
  NC825.F25H384 2010
  743'.87--dc22

                        2010017489

Design by veést design

Printed in China

10 9 8 7 6 5 4 3 2 1

First Edition

To all the furry fanatics and furry artists

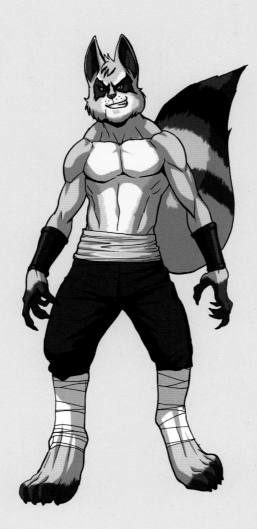

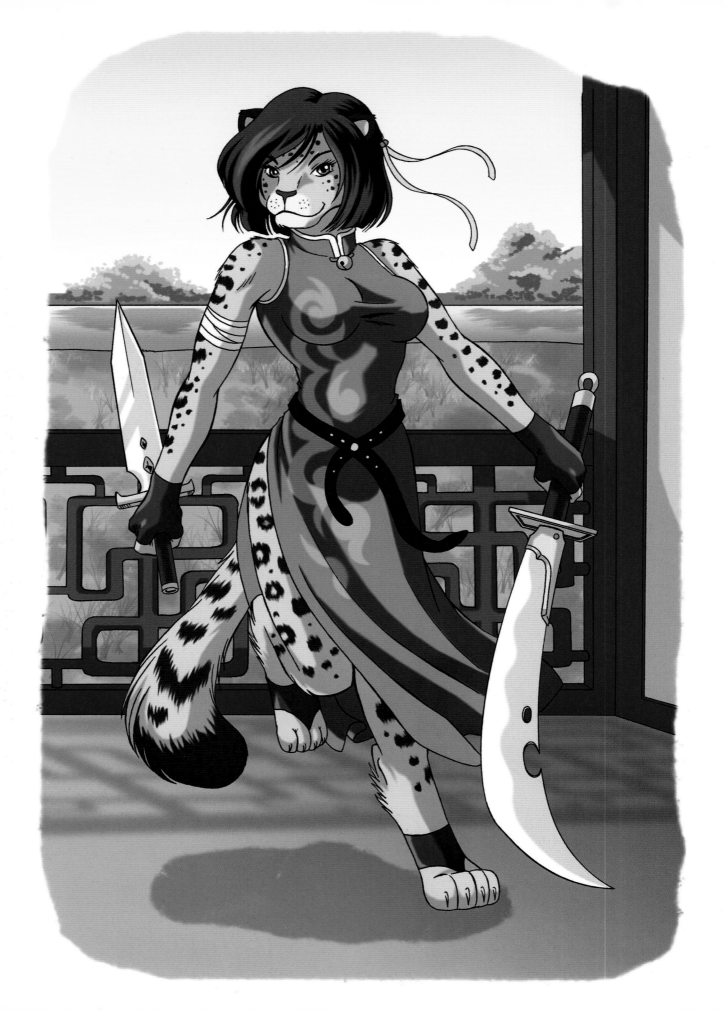

# CONTENTS

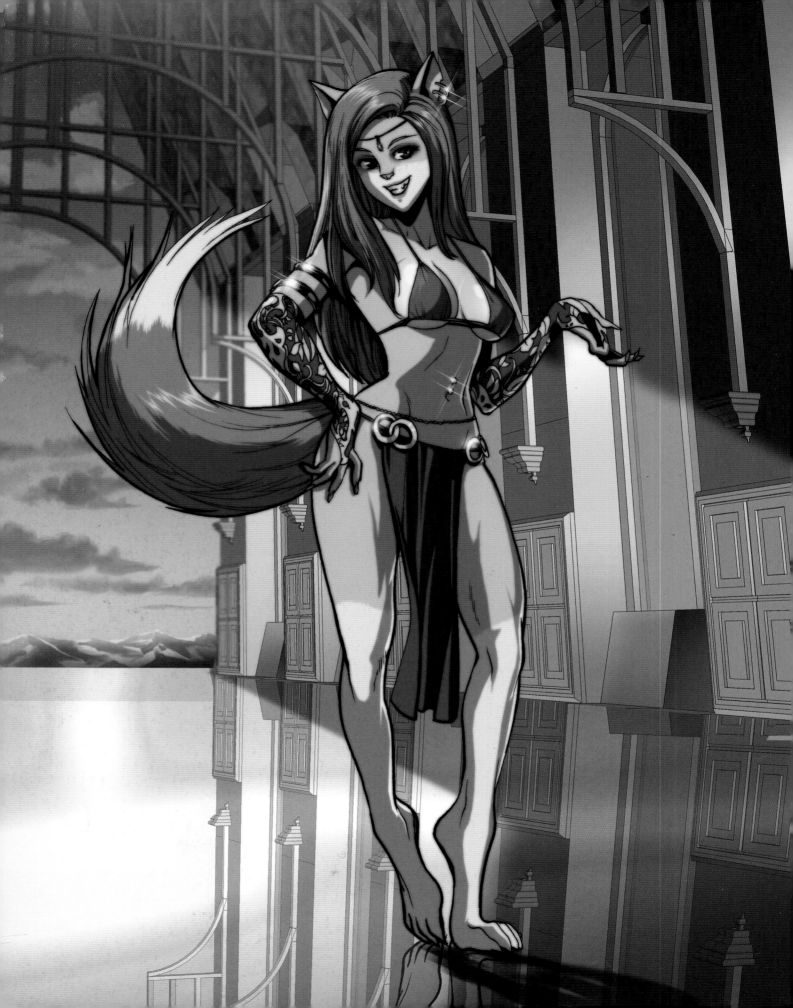

# INTRODUCTION

You have just picked up a book on the cutting edge of art technique. Enter, if you will, the alluring world of furries. Furries are seen in fantasy illustration, comics, and movies. Each year, furry conventions are held all across the country, attended by legions of fans in furry costumes. It's pop culture at its most curious.

Furries are animal-human hybrids. These are fascinating creatures, neither man nor beast but something in between. They stand upright and talk. Some even wear clothes. To draw furries, you need to know how to combine animals and humans—in the correct proportions. Make them too human and they lose their magic; make them too animalistic and they're unable to display complex emotions.

So, what kinds of furries are there? There are cute furries, heroic furries, and adventurous furries. There are retro furries, funny furries, glamorous furries, and even seductive furries. We'll also explore the land of occult and magic, with its wizard and demon furries. We'll enter the enchanted land of fantasy furries, with its goddesses and medieval characters. Yes, it just keeps getting curiouser and curiouser.

If you've ever entertained the idea of drawing furries, then this is your ultimate, gotta-have-it, won't-take-no-for-an-answer type of book. Don't let an opportunity like this pass you by. Look what furries did for the career of Charles Darwin. Yes, Darwin was a furry fan. Used to dress up in a monkey suit and hold danceathons at his estate in the Galapagos Islands. That Darwin.

But do furries really exist? Or are they merely legends, such as Bigfoot and the Loch Ness Monster? There's only one way to tell. Join us. Take the plunge as we go on a guided tour along the road of mystery and into the strange world of furries. Curious.

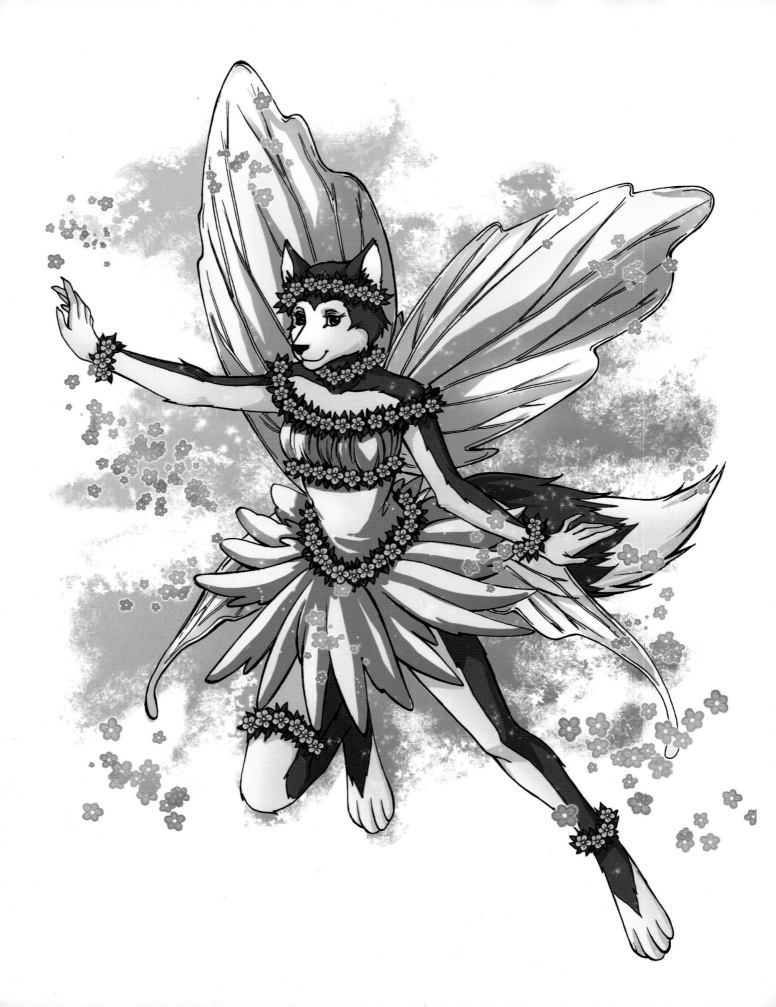

# chapter 1

# What Is a Furry?

A furry is an anthropomorphic being—that is, an animal with human characteristics. There are also furries that are primarily human but with animal traits. Usually, a furry will retain much of its animal personality. So a fox furry will be cunning, a raccoon furry will be mischievous, a lion furry will be proud, and so on. Let's take a look!

# THE VARIOUS FURRY TYPES

The easiest way to create a furry is to draw an animal standing upright, in a human posture, with a human expression. In this way, the character still remains quite animalistic.

Another way to create a furry is to take a primarily human character and add a few animal features, such as markings, a tail, animal ears, and so forth. This book will cover *both* methods of creating furries—and everything in between! Let's check out the polar extremes of furrydom.

Real Wolf

Human-Style Wolf Furry

Animalistic Wolf Furry

# Attractive Furries

When female, furries can be cute and appealing; however, to create an attractive furry, you need to first select an animal that conveys *gracefulness*, such as a fox, cat, or deer. It's not so easy to turn a pig or a goat into a female furry; it just looks like you put lipstick on a pig.

The attractive female furry gets all dolled up. Look at those eyelashes. This is one of the few times that an animal wears makeup. Don't try this at home on your pets. Take my word for it. It just annoys them.

Note how kittenish and playful this pose is, reflecting the furry's catlike personality. Remember: The personality is driven by the character's animal instincts.

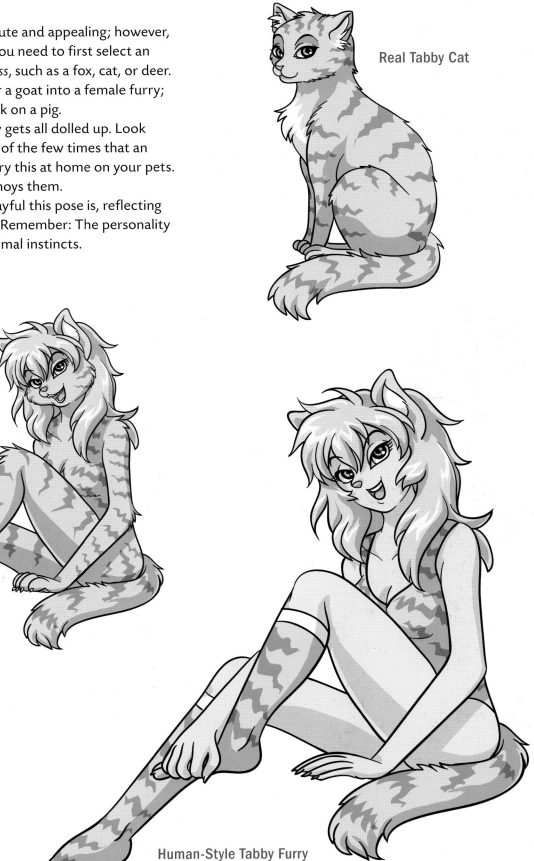

Real Tabby Cat

Animalistic Tabby Furry

Human-Style Tabby Furry

## Four Legs vs. Two

When your character stands on four legs, it looks like a true animal. Even when a human torso is added, it's still mainly animal because it is still on four animal legs. In keeping with that, the face retains strong animal features. But when the character stands on only two legs, as a human does, the face starts to change into that of a human. The character retains only the vestigial signs of the zebra, such as ears, tail, and mane. If the image all the way to the right looks like the "normal" one of the batch to you, you've already passed an invisible furry line of no return. Keep going.

Real Zebra

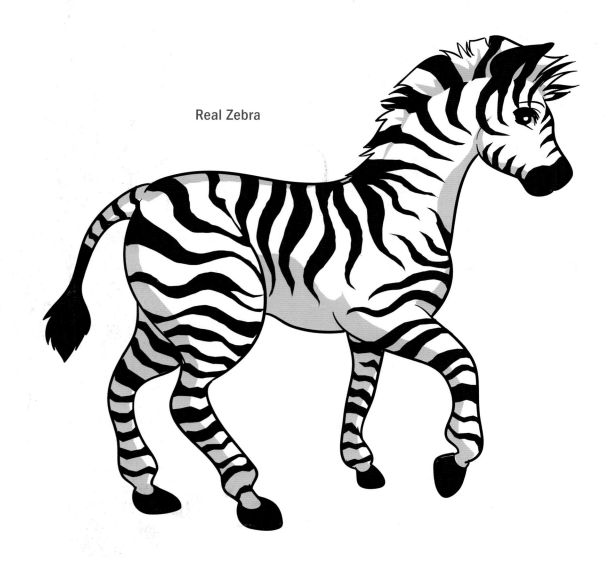

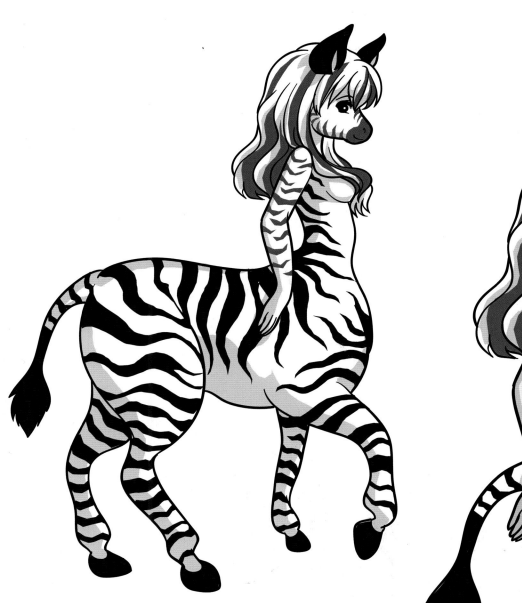

Animalistic Zebra Furry (Centaur Style)

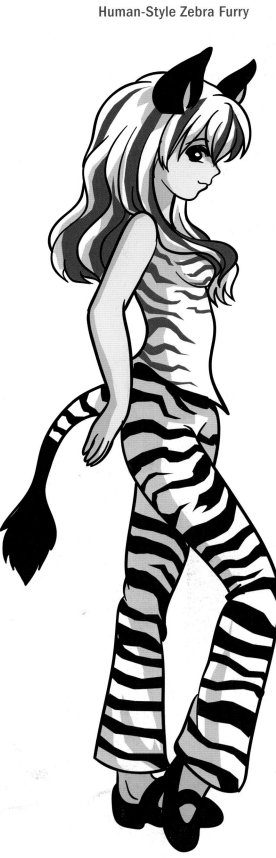

# WALKING THE LINE BETWEEN HUMAN AND ANIMAL

Let's take a look at how far you can push it with human-style furries before they become too animal-like. The ears are those of a puppy. And the tail is a dog's tail. The nose is interchangeable with that of almost any animal, really, because it's so small when drawn on the face that it's not identifiable as being from any particular species. There are even markings on her fur to show that she's a furry.

So with all that, you can't go much further with this character and keep her as a human-based furry. Adding more animal components would turn her into an animal-based furry instead. Animal feet would do it. A muzzle (elongated face) would do it. Right now, we've got her just up to the line between human and animal.

Ears define head as furry.

Tail defines body as furry.

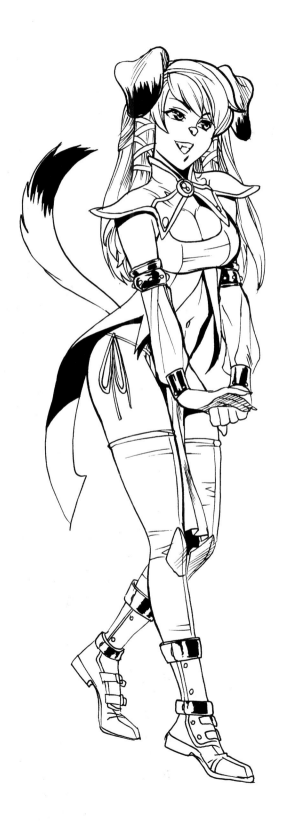

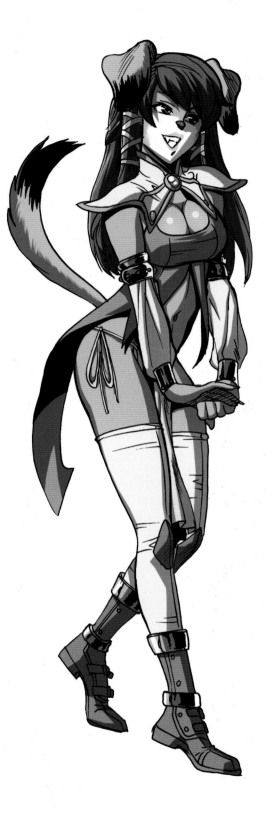

# KEY FURRY DETAILS: THE EYES AND NOSE

In cartoons, you can frequently get away with drawing a single oval for the nose on a wide array of species. But with furries, which straddle the fence between cartoon animals and realistic animals, the one-nose-fits-all approach doesn't always work. The same thing applies to the eyes. So let's take a look at a variety of animals comparing eye and nose styles.

There's no need to memorize these features. This information will always be here for you whenever you want to take a glance at it for reference.

Also note that you're probably not going to use as much detail as is shown here, unless you're drawing a close-up. And it's not imperative that you adhere precisely to these examples as if they're immutable law. Instead, you can adjust these examples to personalize them in your own work. But it's always better to see what the foundation is before you make changes to it.

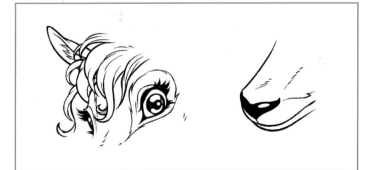

Deer

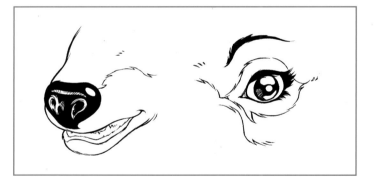

Bear

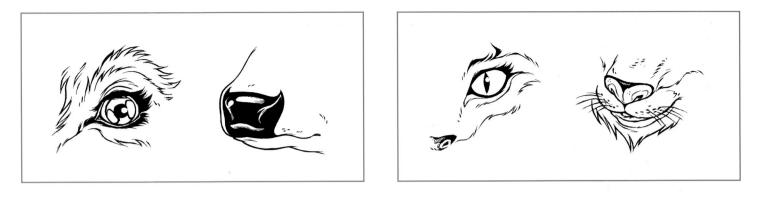

Bull

Cat

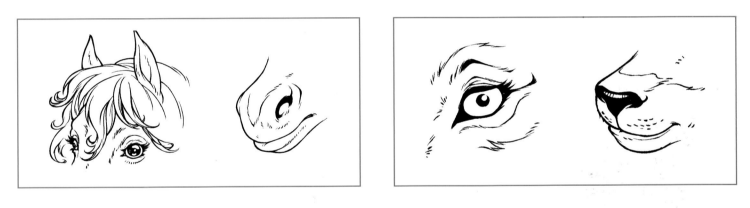

Horse

Lioness

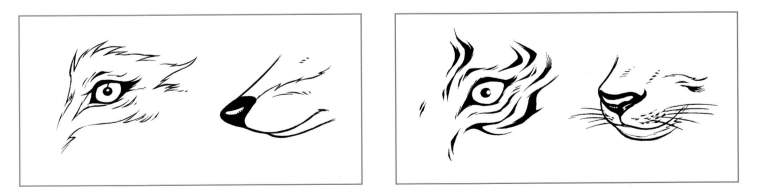

Wolf

Tiger

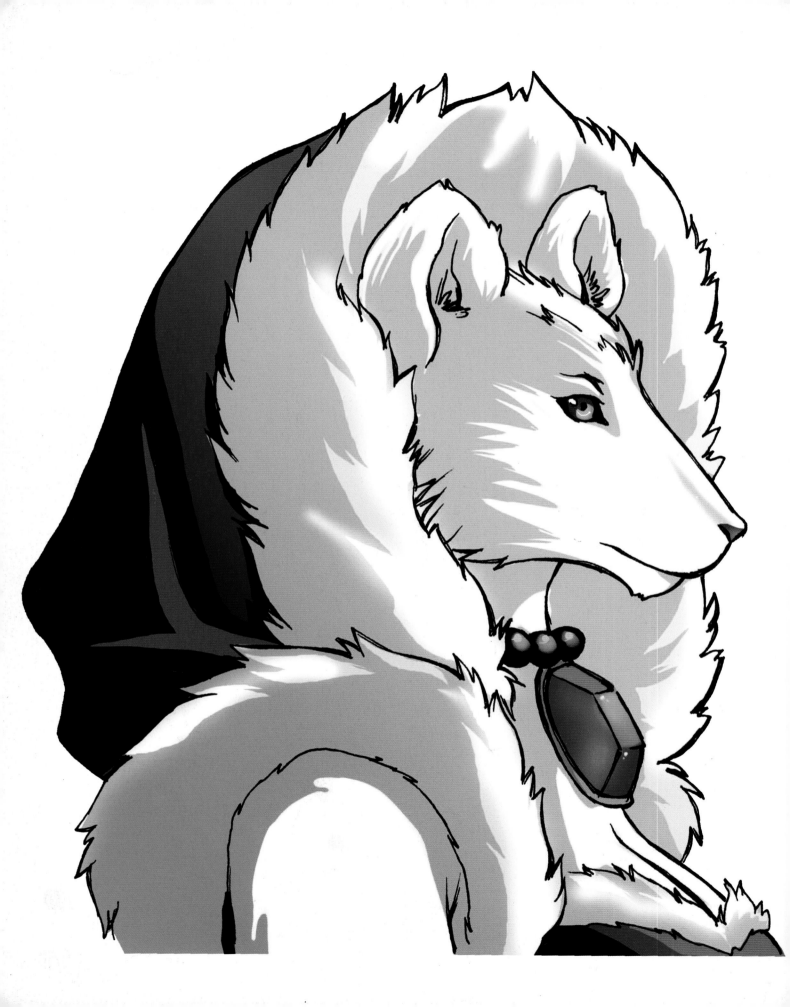

# chapter 2

# The Furry Head

Most how-to-draw books offer only two poor choices: They either present subjects that are so advanced that you can't copy them, or conversely, they present drawings that are so simple that even though you can copy them, why would you want to?

This book offers a better way: appealing, cutting-edge illustrations but with an abundance of gradual, step-by-step instructions so that you can master all of the subjects. You won't have to sacrifice quality to be able to copy the furries in this book. We'll start with the basics and gradually build on them until we've constructed full-fledged characters of the furry domain.

# FRONT VIEW

We're going to start off with some *animalistic* types of furries. Even though these types of furries look like animals, they have advanced thoughts and emotions. This is reflected in the way we humanize their look and expressions. Wolves are popular animal furry types because of their sleek faces and their cunning expressions.

*For the foundation step, sketch in the shape of the head; in this example, it's a circle. Note that the snout of the wolf extends down beyond the skull.*

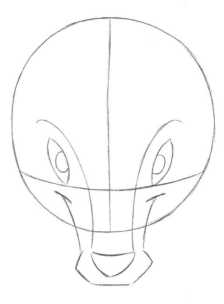

*Widen out the muzzle area surrounding the nose.*

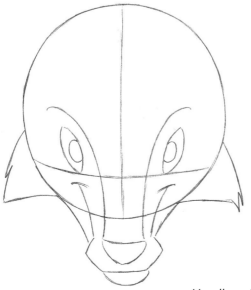

*Usually on furry characters the cheeks are widened, which humanizes them.*

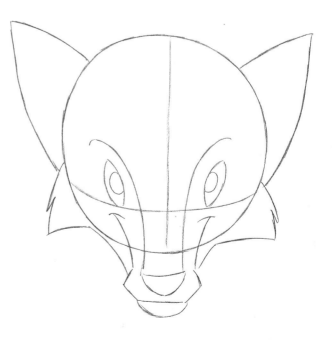

*Ear shapes are very specific according to animal type. Note the pointed ears of the wolf.*

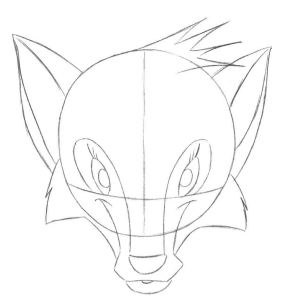

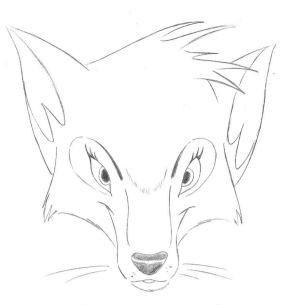

Add dimension to the ear by indicating its interior area. Add noticeable eyelashes, again to humanize the character.

Once you're all done adding in the basic elements, it's time to eliminate the guidelines and sketch marks, or simply trace over your original drawing to make a clean copy. Then carefully go over the lines once more in pencil or ink to polish it up.

You may shade your drawing with pencil or add color to your furry. Popular methods are markers, colored pencil, watercolor, or computer coloring.

# 3/4 VIEW

The snout and skull are really two separate parts, but both the 3/4 and profile views show them as a single, smooth, fused unit.

Of all the animals, the most popular in Furryland are probably the fox and coyote because of their somewhat feminine look. Artists often alter them to create unique species born from the imagination. In this picture, we've added a few spots, a shaggy mane, and some feminine features to create a combo of the two animals that exists only in the fantasy realm.

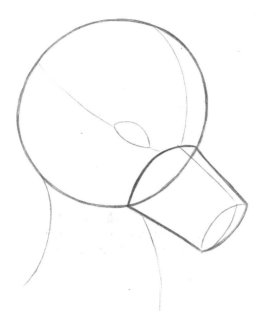

*Note the construction of the skull and snout. On mammals, the snout always protrudes from the skull area, to a greater or lesser degree depending on the species.*

*Add fur to fill out the cheek area on the near side of the face. Note that the front of the muzzle is a flat area.*

*Once the basic elements are in place, smooth out and simplify the outline of the head.*

Unlike real animals, furries are highly stylized, with eye masks, brushed hair or manes, and long eyelashes if they're female. So there's still a lot to do once the basic foundation is locked in place. Add the eye mask, which encircles the eye and then connects to the nose. Also add long eyelashes.

Create shaggy ends on the mane, both at the front over the forehead and in the back behind the neck.

Darken the eyelashes and eyebrow. Shade the eyelid. Add a flower for femininity. Add some random spots—not too many and only a few on the face. Now you've drawn a pretty furry!

# PROFILE

The muzzle or snout gets prominent treatment in every profile, because that's where the face takes shape on a furry. We humans are missing a protruding muzzle. But notice how *all* the furry heads have this feature in common. Short muzzles indicate youth and cuteness. Thin ones indicate glamour. Another thing to look for is a forehead that slants downward along a diagonally sloping line.

## Heavily Feminized Furry

Female furries often look as if they've just returned from a Palm Beach spa. The convention is to portray these heavily feminized furries with a complete makeover, from hair to makeup, expression, and costume jewelry. This removes them from the real world of animals, in which it's often difficult to distinguish the male from the female of the species, and thrusts them into our contemporary world. Now she looks ready to meet with her furry divorce attorney.

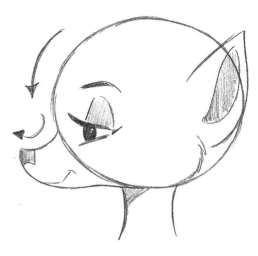

*Note the sweep to the front outline of the face.*

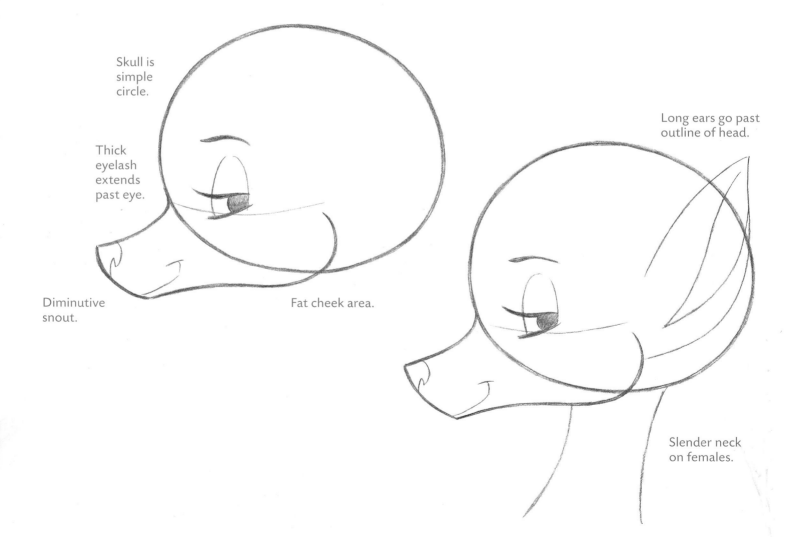

Skull is simple circle.

Thick eyelash extends past eye.

Diminutive snout.

Fat cheek area.

Long ears go past outline of head.

Slender neck on females.

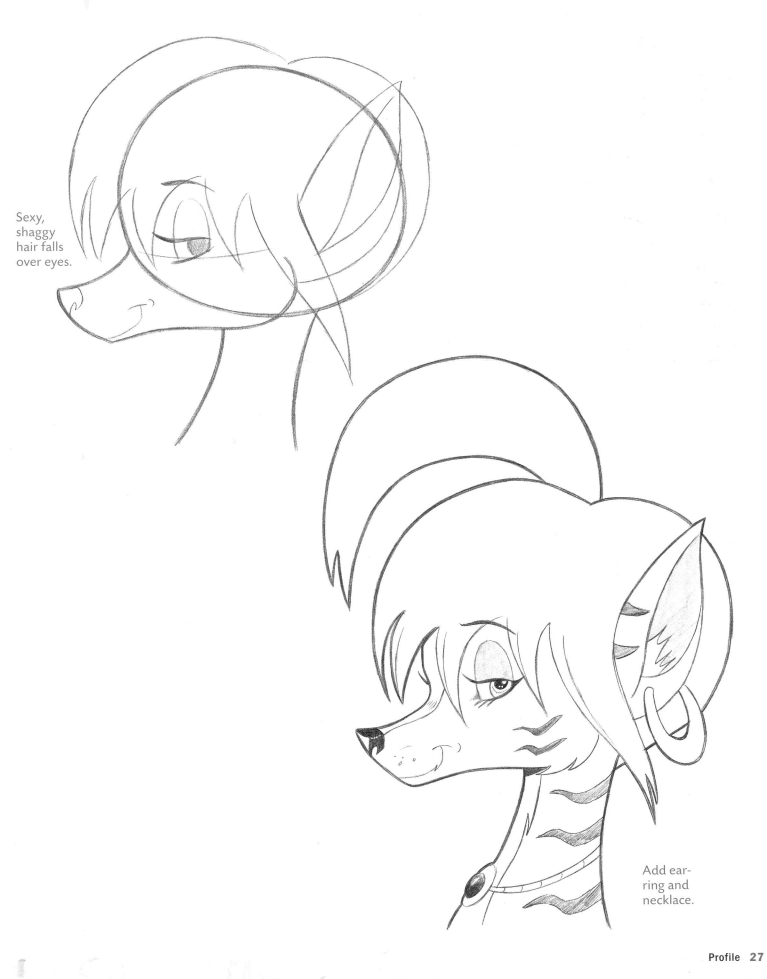

Sexy, shaggy hair falls over eyes.

Add earring and necklace.

# Lion

The lion maintains a regal look when drawn standing upright as a furry. Note that the head naturally tilts downward (the bridge of the nose isn't parallel to the ground). The mane continues all around the head, even under the chin. The chin is pronounced.

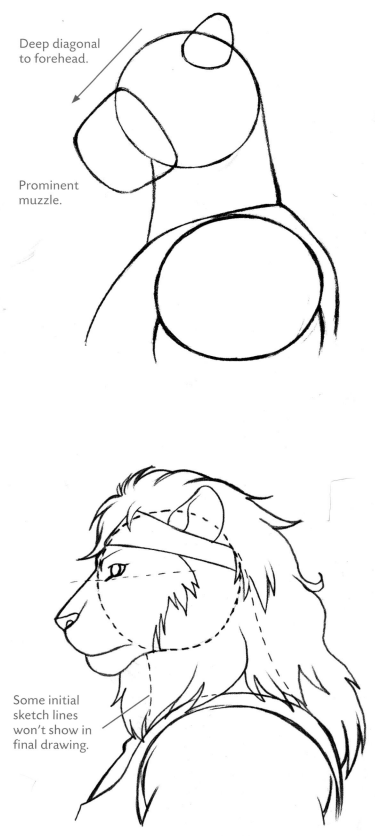

Deep diagonal to forehead.

Prominent muzzle.

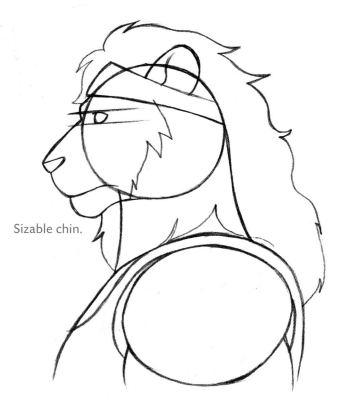

Sizable chin.

Massive shoulders.

Some initial sketch lines won't show in final drawing.

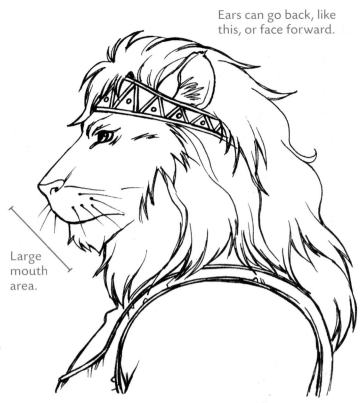

Ears can go back, like this, or face forward.

Large mouth area.

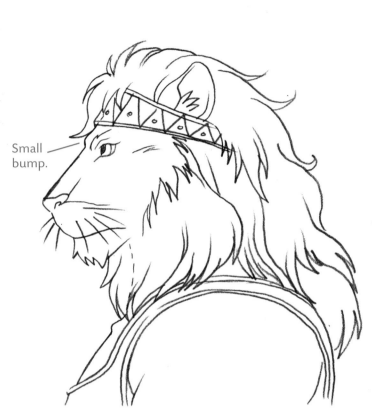

Small bump.

## LION PROFILE SPECIFICS

The lion furry cuts a strong profile, with only a small bump in the middle of the forehead just above the eyes. The front of the mouth is decidedly large and takes up quite a bit of room.

# Tiger

The tiger furry starts out like a lion at the nose, mouth, and chin but then borrows some of the fluffy cheeks and tabby stripes of a cat. Still, I wouldn't toss this guy a ball of yarn and play tug-of-war with him. That gigantically thick neck gives him a heroic posture, and a touch of armor doesn't hurt, either. Notice that the stripes radiate outward from the eye over the rest of the face. Some beginners draw thick stripes and only succeed in making the tiger furry look like a prisoner from some old silent movie. And you don't want that.

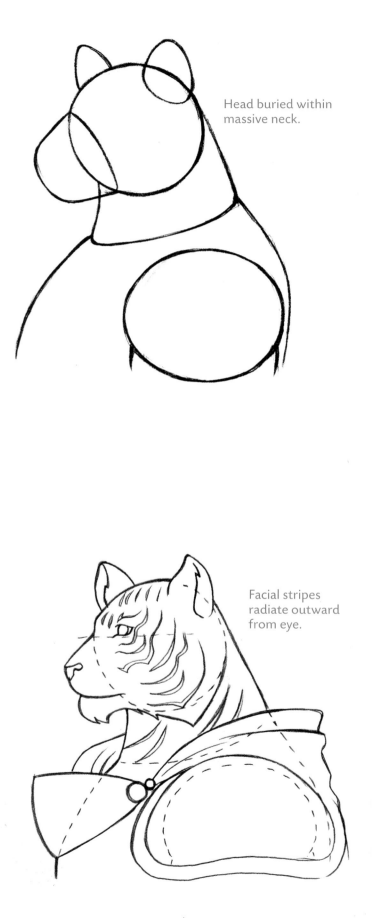

Head buried within massive neck.

Small, deeply set eye.

Facial stripes radiate outward from eye.

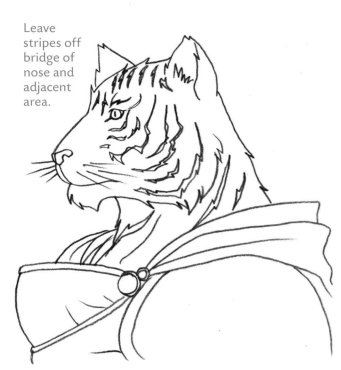

Leave stripes off bridge of nose and adjacent area.

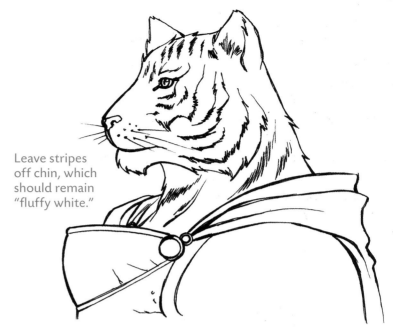

Leave stripes off chin, which should remain "fluffy white."

## TIGER CHARACTER TYPES

In Furryland, the tiger can be cast as a noble and even-tempered commander who weighs his options carefully before committing his troops to battle. You can go against type, taking what we expect to be a savage character and turning him into a sophisticated and reserved one. It can make the experience more memorable for the audience if you cast your character against expectations—against type.

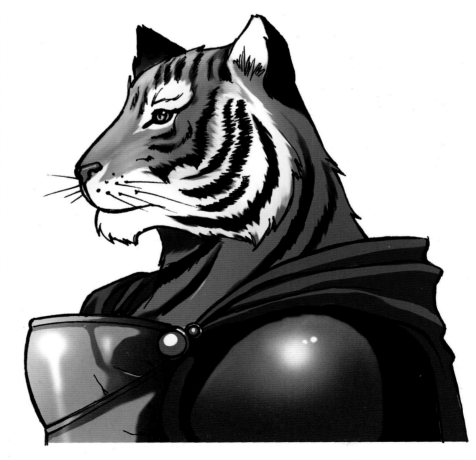

## Snow Fox

Creatures of the snow have a magical element to them in the fantasy genre. And get this contradiction: Artists use them to represent extreme goodness or total evil. Don't ask me why. I'm just the messenger. Think of a snow queen. She's either all good or all bad—but nothing in between. Who makes up these rules? I don't know, but as artists, it's important that we stick to them to fulfill audience expectations.

So here's the snow fox. She's beautiful and imbued with magical powers, as you can tell from that crystal she wears. Crystals always have special powers. Another rule. Go figure.

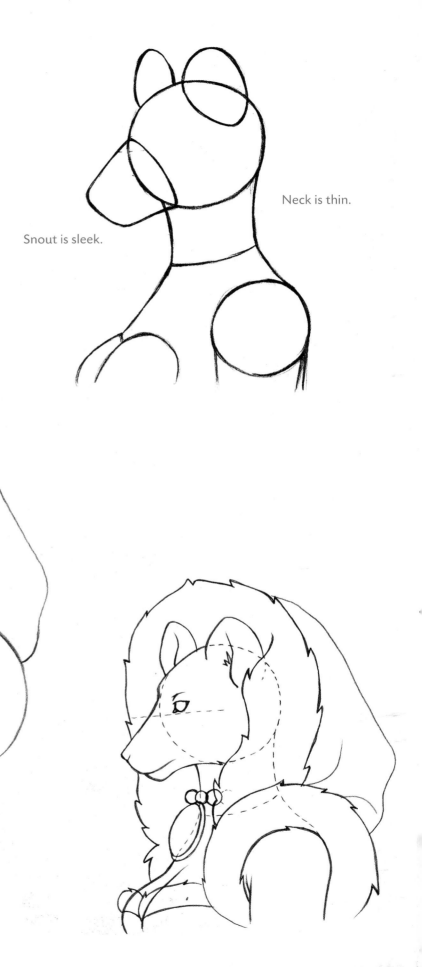

Snout is sleek.

Neck is thin.

Head shaped like that of adolescent wolf.

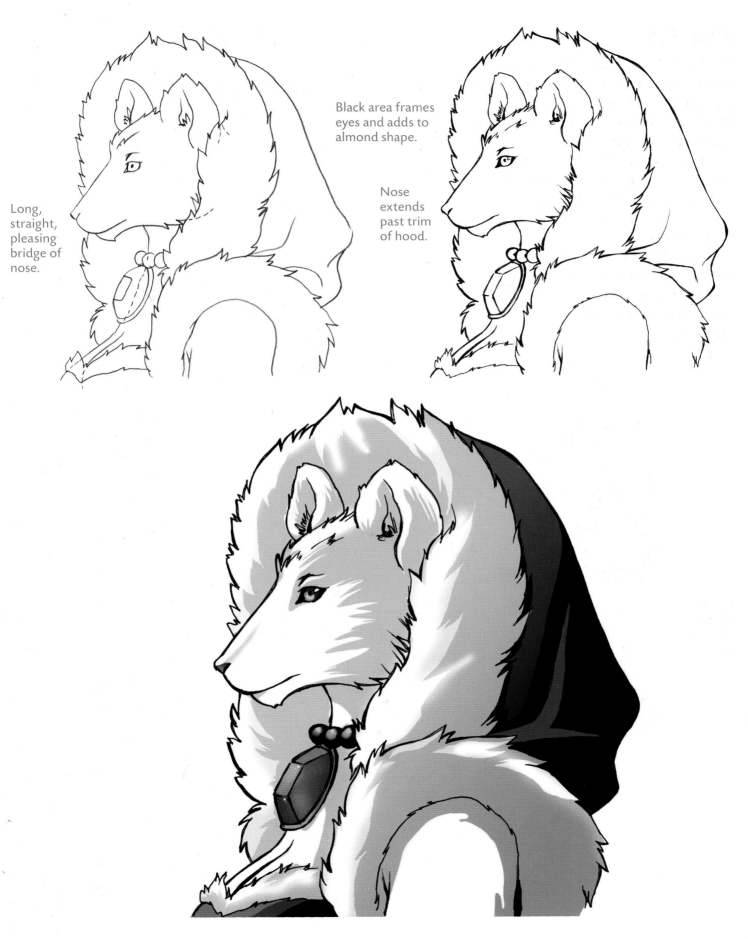

Long, straight, pleasing bridge of nose.

Black area frames eyes and adds to almond shape.

Nose extends past trim of hood.

# Unicorn

Unicorns originally were portrayed as fierce fighters, but their image eventually evolved into one of the graceful, tranquil beings that we've come to know and love today. They are usually female. But even when they're male, they are androgynous. For unicorns, create a horse's head but without the massive jaw you would find on a powerful, masculine steed. Soften everything about this fanciful creature. The eyes, mane, and nose all should be drawn with a degree of subtlety. The mane masks the superthick neck, and this helps humanize the beast.

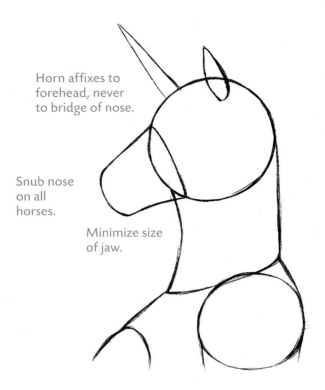

Horn affixes to forehead, never to bridge of nose.

Snub nose on all horses.

Minimize size of jaw.

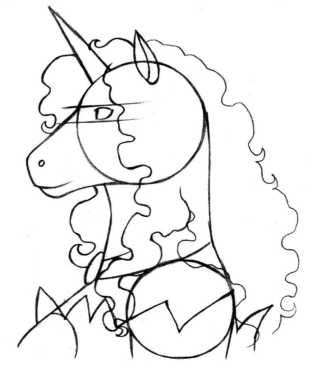

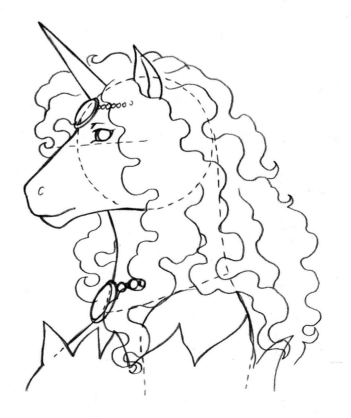

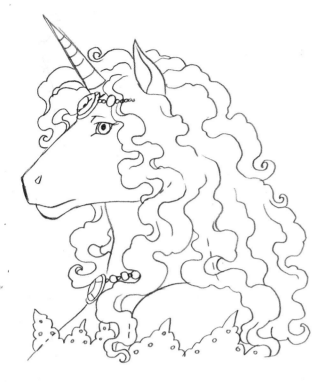

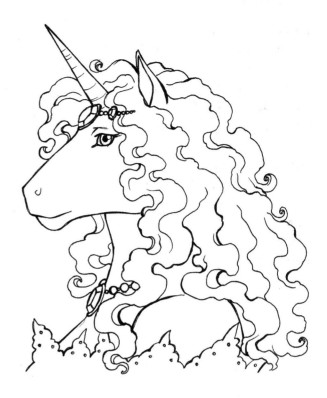

## UNICORN DETAILS

Heavy use of "eyeliner" is recommended. Add a definite style to the mane. The one shown here is wavy. Yours could be long and flowing or short and breezy. But either way, create a look for it. Note how the mane is superabundant, overflowing with rapturous hair that's dreamlike in its effect. Forehead jewelry and a necklace bring out the magic that's at this furry's essence.

# CHARACTER CONSISTENCY IN DIFFERENT ANGLES

One of the most puzzling problems for any artist is how to draw a character's head from different angles—and still make it look the same. Why all this emphasis on drawing different angles? Because drawing a character in different angles will raise your skill level exponentially. In addition, it's highly practical. Dramatic moments and action poses require a variety of shots. You can't draw everybody in a front view. That would get repetitious.

Why do artists often find this consistency a difficult nut to crack? The problem lies in the fact that many beginners start drawing without first focusing on the underlying structure of the head. Where and how the features are placed on the head changes along with the new tilt or angle. Therefore, it's best to go back to the foundation stage when you shift angles. Start with the circle for the skull and map out the head from the beginning. Even pros map out complex poses in a rudimentary fashion before going on to finish the drawing. But beginners often want to leave the basics behind as fast as they can. It may sound like a paradox, but it's true: The longer you stay with the basics, the more advanced your drawing will be.

## Front View
In the front angle, the nose dips down somewhat, making the snout appear longer. Note that the eyes, eyebrows, and mouth are positioned symmetrically around the vertical center guideline; this keeps the left side of the face looking the same as the right.

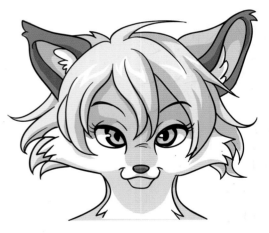

## Profile
Notice here that the cheek and the ear don't attach to the back of the skull, as one might assume, but are placed toward the middle of it, leaving a good amount of mass behind them. The eye is set back from the outline of the profile and not pressed up against its perimeter.

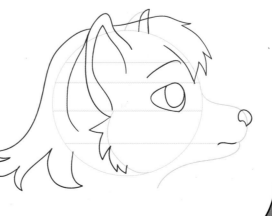

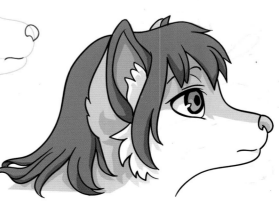

## "Up" Shot

In an "up" shot, you're looking up at the character, as if the character were standing above you. You can also use the up shot to portray a dramatic moment when you want the character to look majestic. Notice that this angle cuts off your view of some of the wolf's features.

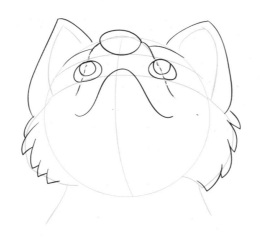

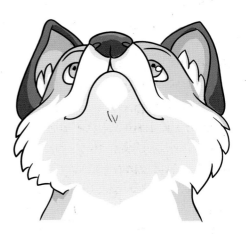

## "Down" Shot

The jaw is hidden from view in this angle, but everything else can be seen. The features, like the eyes and eyebrows, are placed very low on the head. Notice that the cheeks are also formed very low on the head. This is a sympathetic angle.

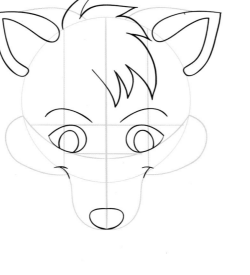

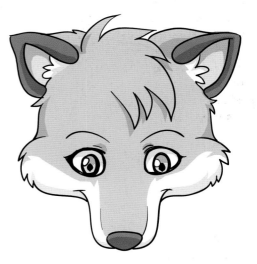

## 3/4 View (Open Mouth)

This is a widely used angle, great because it shows a lot of the face. All of the features are evident: both eyes and both ears. Therefore, you can get a lot of expression in a pose drawn at this angle. This is a pleasant angle for a character.

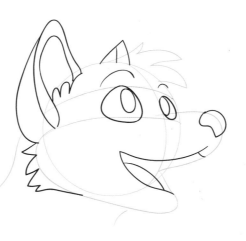

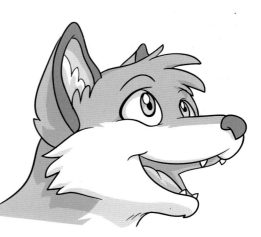

## 3/4 View

Notice that the far eye is always drawn on the far side of the center line. And since the effects of perspective are evident in this angle, the far eye is also drawn narrower and smaller than the near eye. The far ear, likewise, is smaller than the near ear, also due to the effects of perspective.

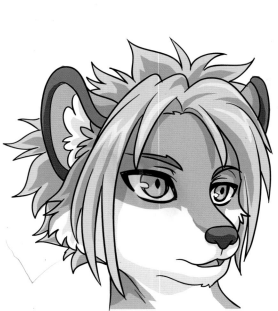

## 3/4 "Up" View

You can also take the 3/4 view and adjust it by adding a secondary angle—in this case, an "up" shot. A character looks admirable when seen in this angle.

## 3/4 "Down" View

The secondary angle in this 3/4 view is a "down" shot. This has the effect of making a character look weak. Use it for situations in which you want your character to look like he's in trouble.

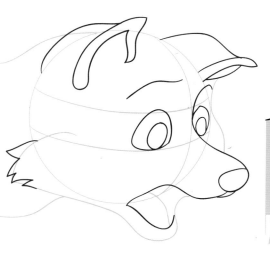

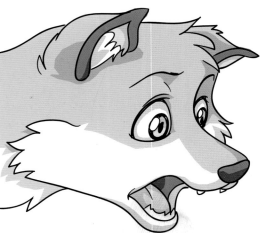

## Sideways Head Tilt (Front View)

A cocked head is a cute way to show a little attitude. Add a curl of a smile and a raised eyebrow and you've got a charming rogue of a character. Be sure to add enough of a slant to your horizontal guidelines so that the head appears tilted.

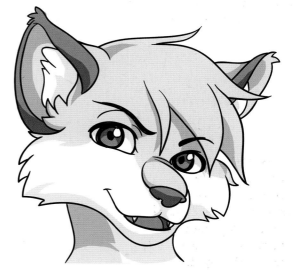

## Sideways Head Tilt (3/4 View)

The sideways head tilt, with eyes opened wide, is an endearing look—producing a puppy-dog type of charm. Make sure one ear is drawn higher than the other, one eye is drawn higher than the other, and one cheek is drawn higher than the other to ensure a successful result.

# FURRY EXPRESSIONS

Here's the secret about drawing animal faces: They can be more expressive than human faces. Guess that's the last time someone tells me a secret. I mean, they tell me, and I go and put it in a book. Can't get much worse than that!

Anyway, the reason why furry faces are more expressive than human faces is because furries have more to work with. In addition to eyes, eyebrows, and mouths (which humans have), furries also have ears that can express emotion by moving up or down, bushy cheeks that can ruffle when surprised, and a muzzle/snout that can squash and stretch. So let's have some fun and see how we can manipulate these features to create furry expressions.

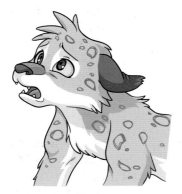

### Fearful
The jaw hangs slack, the ears go down, and the eyebrows, most important, crush toward the center of the forehead.

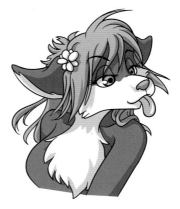

### Teasing
When the tongue sticks out, the rest of the mouth is closed. The tongue isn't stiff but bends downward slightly.

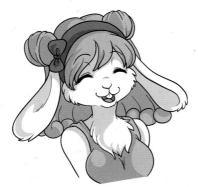

### Happy
The eyes close, curving downward. Bunch the cheeks outward, and draw a smile that curves up and in, toward the nose.

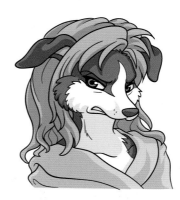

### Contemptuous
The mouth tugs back into a grimace. The character makes a sidelong glance, with irises looking out of the corners of the eyes. The eyebrows push down on the eyes. The ears flop forward.

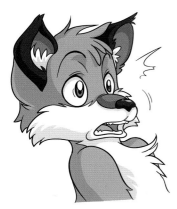

### Surprised

The eyes open wide, and the eyebrows arch up above them. The mouth drops open, and the character leans back in shock.

Note the *motion lines* around the character, further emphasizing the backward-moving thrust to the body.

### Bashful

Tilt the head down, but have the eyes look upward. Also include a tiny, sheepish grin.

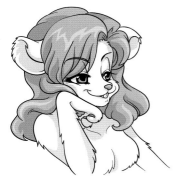

### Flirtatious

Note the half-closed eyes with the line of the eyelashes touching the pupils. The eyelashes are extra thick and cascade off the eyes.

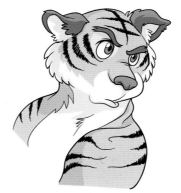

### Suspicious

The sideways look combined with a tilt of the head is always a good pose for suspicious behavior. The eyes should narrow, and the mouth should show slight displeasure.

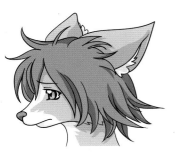

### Sad

The gaze should be cast slightly downward for a look of sadness. The eye has a big shine in it to make it look watery. Note that the ears face back.

### Making a Decision

One eyebrow is up; the other one is down. The top lip tucks tightly into the small bottom lip. Make sure to draw the line that goes from the bottom of the nose down to the bottom lip.

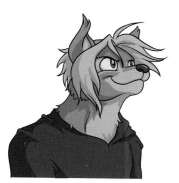

### Assertive

Here's one that is counterintuitive: The eyebrows actually form a slight frown, while the mouth smiles. Make the chin somewhat pronounced. The ears face forward.

### Embarrassed

This is similar to a sad expression, except that the shoulders rise and the body tenses up. The mouth is small and taut.

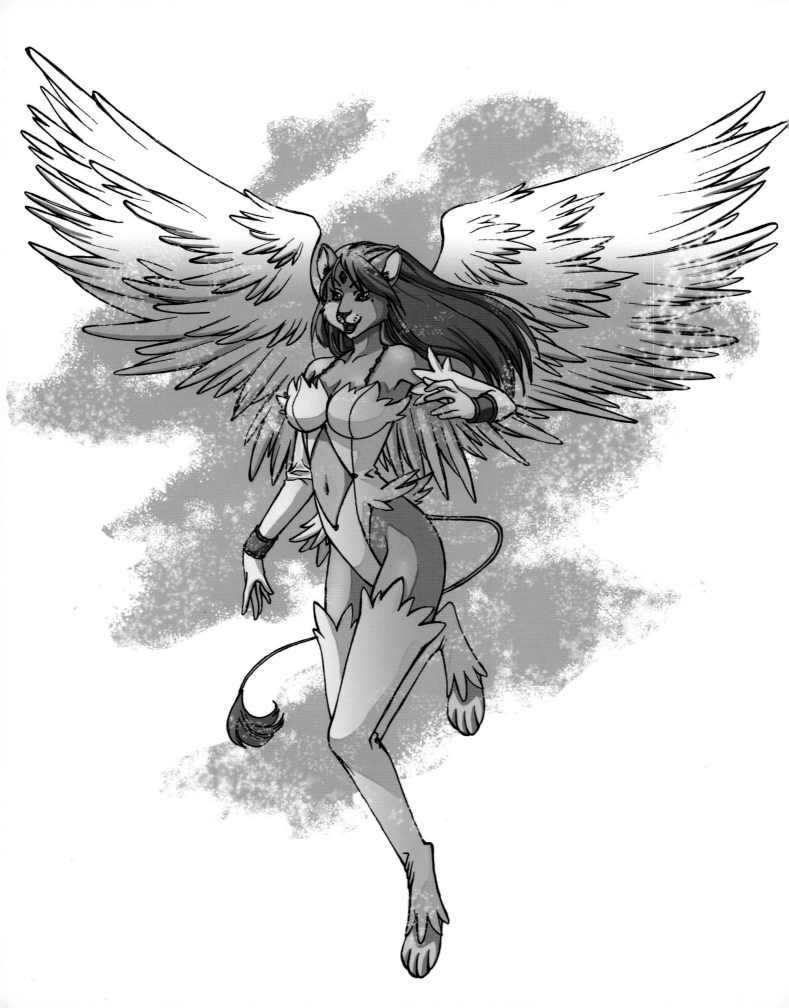

# chapter 3

# Furry Anatomy & Body Language

The information on animal anatomy in this chapter is reader friendly and doesn't require memorization. There are no difficult-to-pronounce Latin names for the muscles and bones. (People who know a tibia from a fibula simply have too much time on their hands.) Just eyeball the pages, and try to "get it" conceptually. Unless you learn the basics of how an animal body is built, especially the "arms" and "legs," it's hard to draw it convincingly. That's because the limbs seem to bend the wrong way on animals. But this chapter will show you—in a *simplified* manner—just how the joints are configured and how to adjust them to create furry characters.

# COMPARATIVE ANATOMY

Externally, animals look quite different from one another. Besides horns, ears, tails, manes, and snouts, even their postures differ based on their species. Internally, however—and this is the good part—most mammal skeletons are basically the same configuration. Once you know how one mammal's body is built, therefore, you will automatically know how to draw most any type of mammal. Eyeball the forelegs and hind legs in these examples. All of their joints bend in the same general direction. Sort of takes the mystery of out drawing animals, doesn't it? That's the idea!

Now that you see how it's done, you can take this knowledge and apply it to drawing furries—all kinds of furries—because most furries are based, to some degree, on animal anatomy. It won't ever get more complicated than this. And if you run into difficulty, you can always turn back to this page for answers.

**Dog (Wolfhound)**

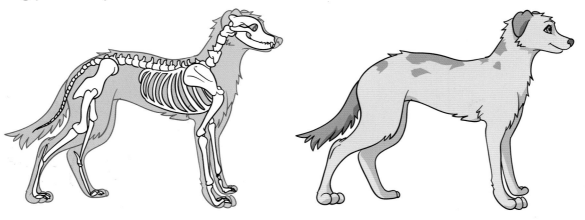

**Fox**

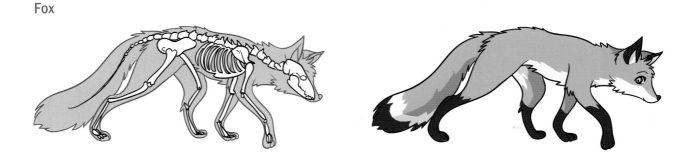

Lion

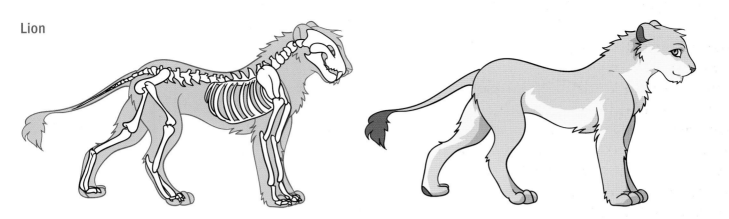

Cat

Cougar

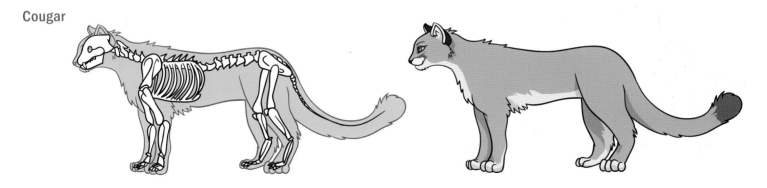

Impala

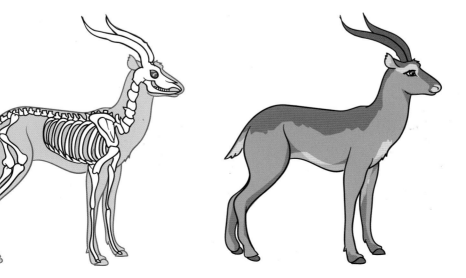

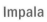

# ARMS AND LEGS

The arms of furries mimic human arms and generally bend at the wrist when in the relaxed position. It's the legs that often present more of a challenge for artists. So let's take a closer look at them. But first we'll simplify things by using a stick-figure skeletal diagram inside of the body outlines.

**Furry Arms**
Similar to human anatomy, furry arms bend at the wrist and elbow.

Elbow ▷

**Realistic vs. Furry Deer Legs**
Notice that the "realistic" deer stands horizontally (on all fours); yet, its leg configuration is similar to that of the furry, who stands vertically. This ought to be taught in every high school biology class, because believe it or not, they don't offer very much in the way of furry studies. Most of it is about DNA and other useless stuff like that.

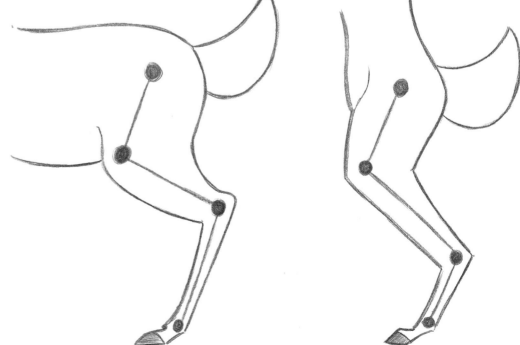

# Hind Legs

Looking at the wolf, you see that the hind leg zigzags when the knee is *deeply bent* in a standing or walking position. Notice, too, that the leg actually has four separate sections.

The lion shows what happens when the feet are turned outward: Both knees stick out in a funny way. Again, the legs are made up of four distinct sections.

# ANIMAL LEGS VS. HUMAN LEGS

Over the past few pages, the furries have stood upright in a human posture. But the leg-joint configuration has remained animal in form. Now we'll take it one step further up the evolutionary scale by turning their legs completely human. Therefore, instead of a backward-bending knee joint, the legs will have a single joint in the middle, just like a human's knee. That will make it easier to draw, too.

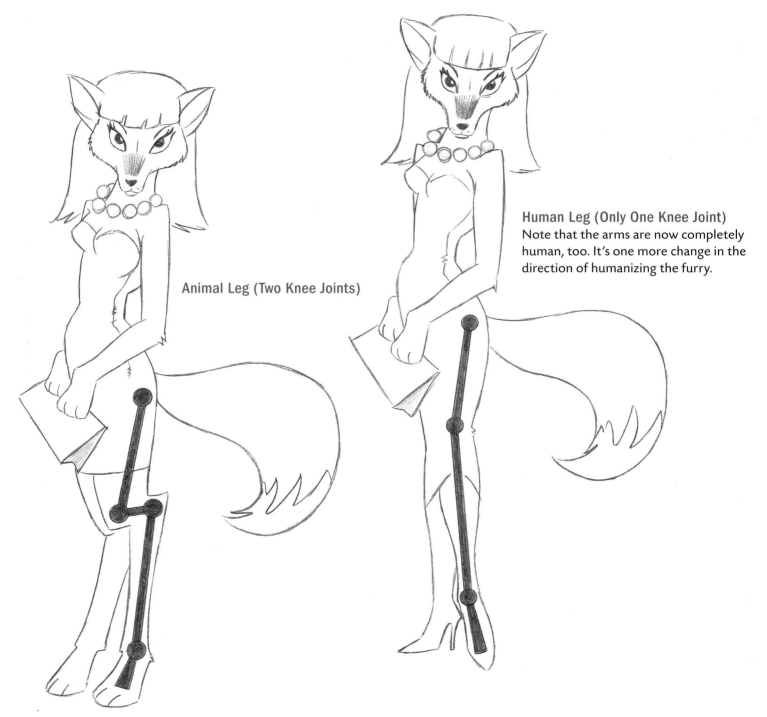

**Animal Leg (Two Knee Joints)**

**Human Leg (Only One Knee Joint)**
Note that the arms are now completely human, too. It's one more change in the direction of humanizing the furry.

## SPECIAL HINT: FEET

Subtleties can make all the difference. When a furry mimics human anatomy, like this cute rabbit character, pay special attention to the legs. Yes, the legs have been drawn to look human, but what about the animal's feet? The feet are an important part of the character's design, just like its ears, for example. Specifically, rabbits have huge feet with fluffy "toes." It may be tempting to shorten the feet to humanize them, but it's often better to resist this approach. Humanizing the feet risks destroying the basic identity of the animal on which the furry character is based. So usually we try to keep them as they are on the original animal.

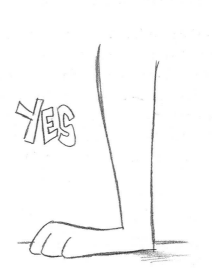

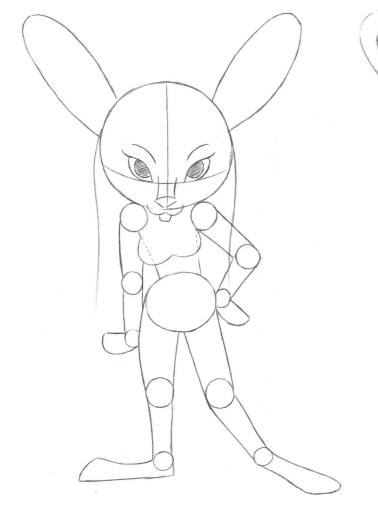

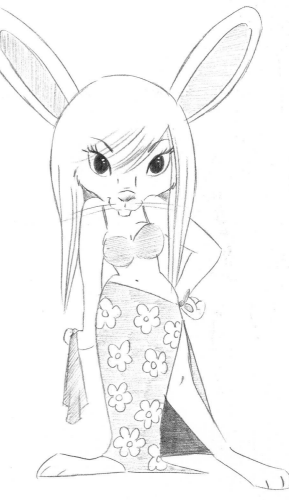

# HIP ACTION

This character is much more human in treatment than the previous types we've been drawing so far, because she's meant to be attractive. To that end, the animal qualities are minimized and are just used as important accents and flourishes instead of as the foundation.

This means that we're concentrating on drawing the figure with more human anatomy. And this type of character is going to have a killer figure: square shoulders, narrow waist, wide hips, and long, slender legs.

The tilting of the hips, at a hard angle, is also key here and makes the pose look relaxed and natural—but, most of all, it sets in play some important body dynamics. Let's take a look: The straight leg (our left side) shoves the hip on that side of the body upward. As a result, that hip tilts, sending the right side downward. The right leg then has less room, so it has to bend, and bend it does, behind the front leg. The back arches to counterbalance. Note the tail, which creates a counterbalancing curve, as well. All of these counterbalancing shifts add up to a dynamic pose. We'll also give this character a cute outfit and a flirtatious, playful look, which is so popular among furry fans. You know who you are.

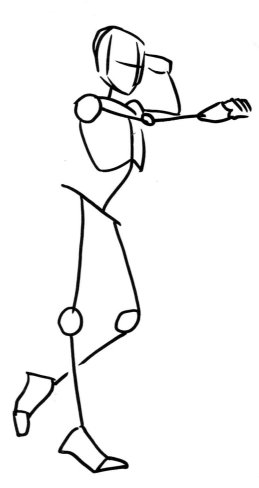 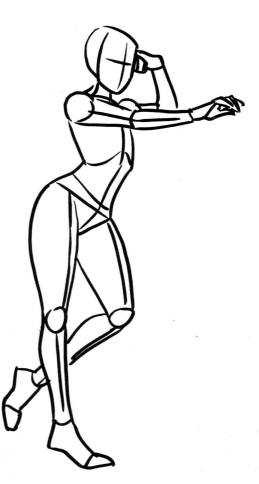

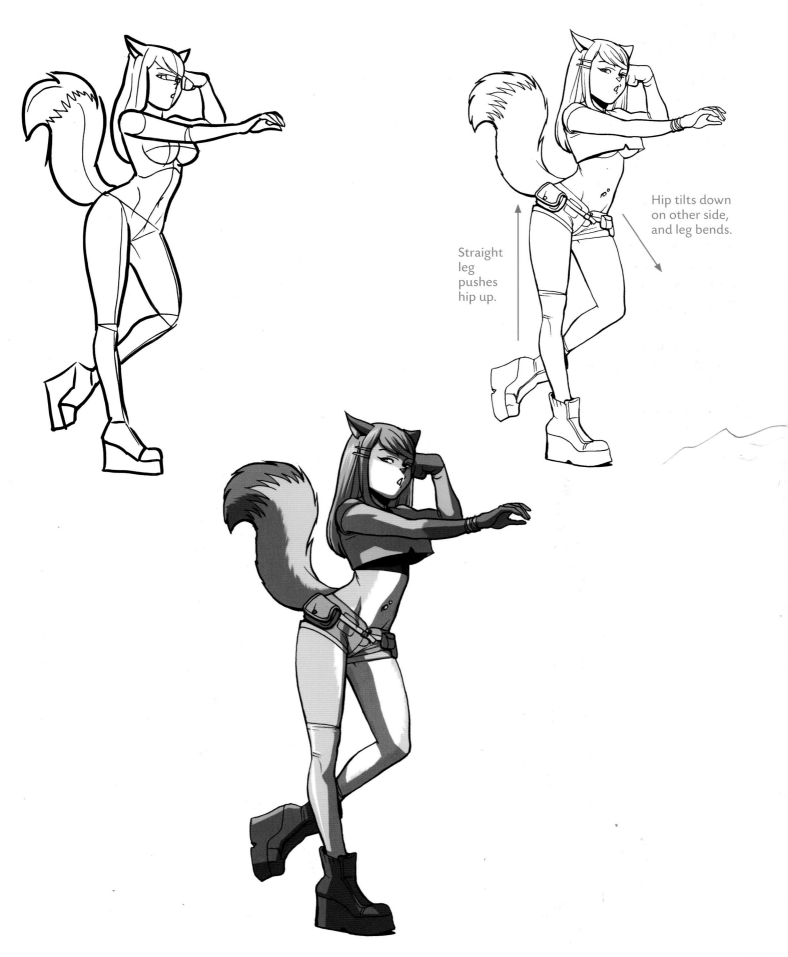

Straight
leg
pushes
hip up.

Hip tilts down
on other side,
and leg bends.

# STRETCH AND CRUNCH

Here's a good, solid 3/4 view of the body in a symmetrical pose. In a pose like this, it's very important to draw the center line two-thirds of the way over on the body to indicate the effects of perspective on the figure. Also note that the indentation at the waistline isn't equal in front and in back. The stomach area in front is rather flat, but the arch in the back indents quite a bit. That's because the stomach is *stretched*, but the back is *crunched*. Note: Elbows bent, over the head, is a classic pose used in many life-drawing classes.

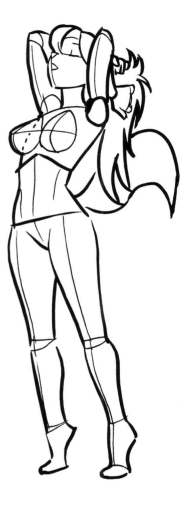

Center line isn't centered in 3/4 view.

*Due to the effects of perspective, in the 3/4 view the near breast is drawn in a 3/4 view, while the far breast is drawn in a side view.*

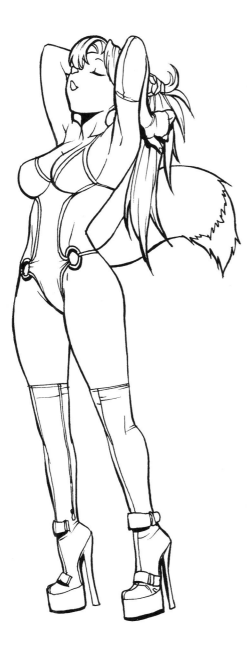

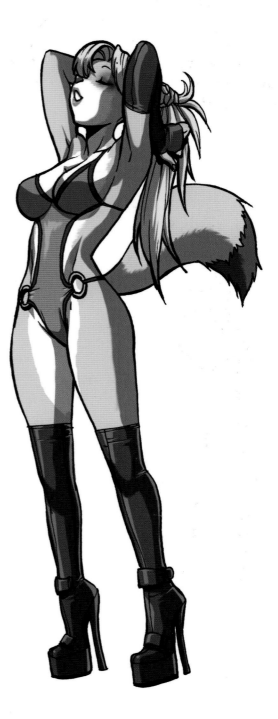

# COUNTERBALANCE

Note the counterbalance in this pose, which makes it interesting: One side emphasizes a bent leg, while the other emphasizes a bent arm. And this is a good example of a female arm. There's a tendency among beginners to draw female arms straight, like pipes. Beginners do this to avoid giving female characters big arm muscles, which might make the arms look like guys' arms. But as you can see, there's no chance of that happening. Instead, give her *slender* arms, but *contour* the muscles anyway. Just don't define any of the interior muscles of the arms, as you would on a guy. Also note the difference in the shape between the cat tail here and the fox tail on page 53.

Bent leg is paired with straight arm on same side of body.

# GESTURE SKETCHES

Up until this point, we've been exploring the individual principles used in drawing the furry body. Now it's time to put them to good use. Gesture sketching is just that: sketching to capture the essence of the movement, the attitude, the feeling, the pose, the expression that is communicated through body language. We're like musicians, we artists, warming up before we start to play. So don't worry if you hit a wrong chord now and again. This isn't for show. Gesture sketching is where you work out the kinks in your drawings and loosen up. Generally, gesture sketches stay in your sketchbook, unless you accidentally create a masterpiece, of course!

Emphasize how your character bends, twists, leans, and so on. Keep the gestures light and energetic: perky, vivacious, nuanced, fun loving, flirty, quizzical. Just quick sketches—nothing final—so don't worry if they're a little rough to start off. Erasing is fine; so is drawing over the image a few times.

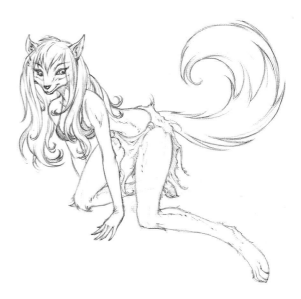

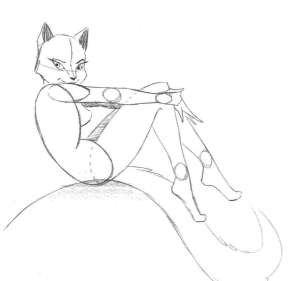

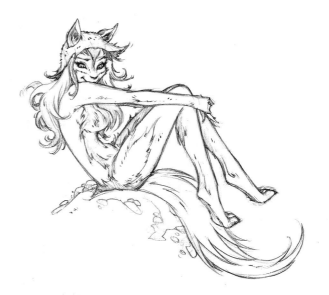

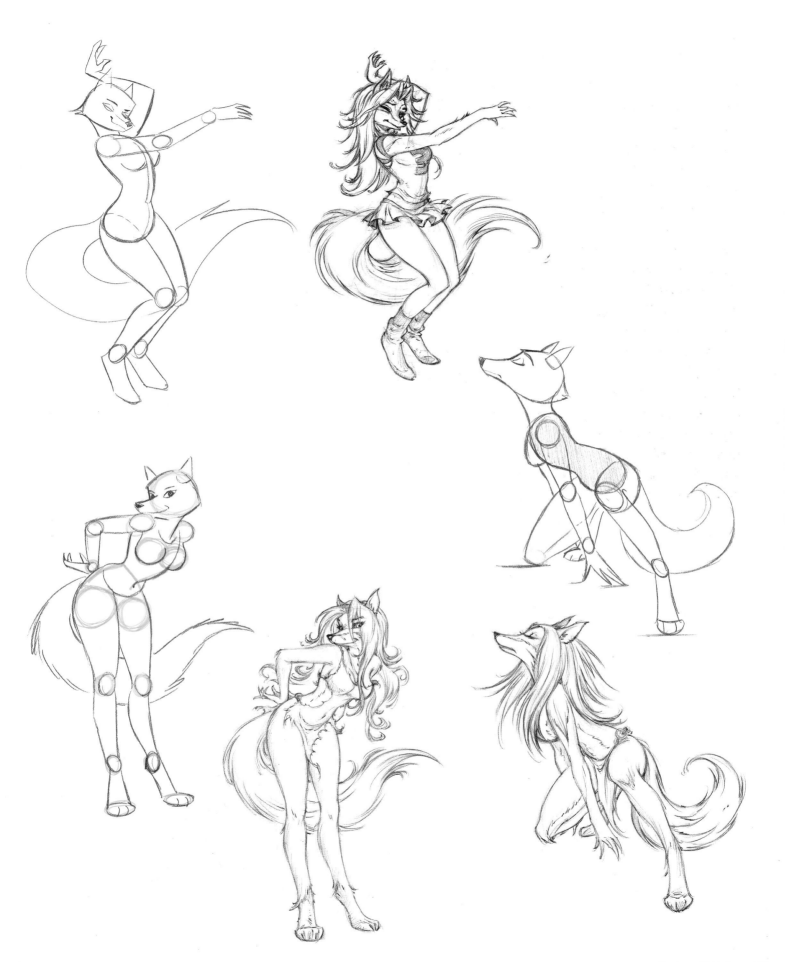

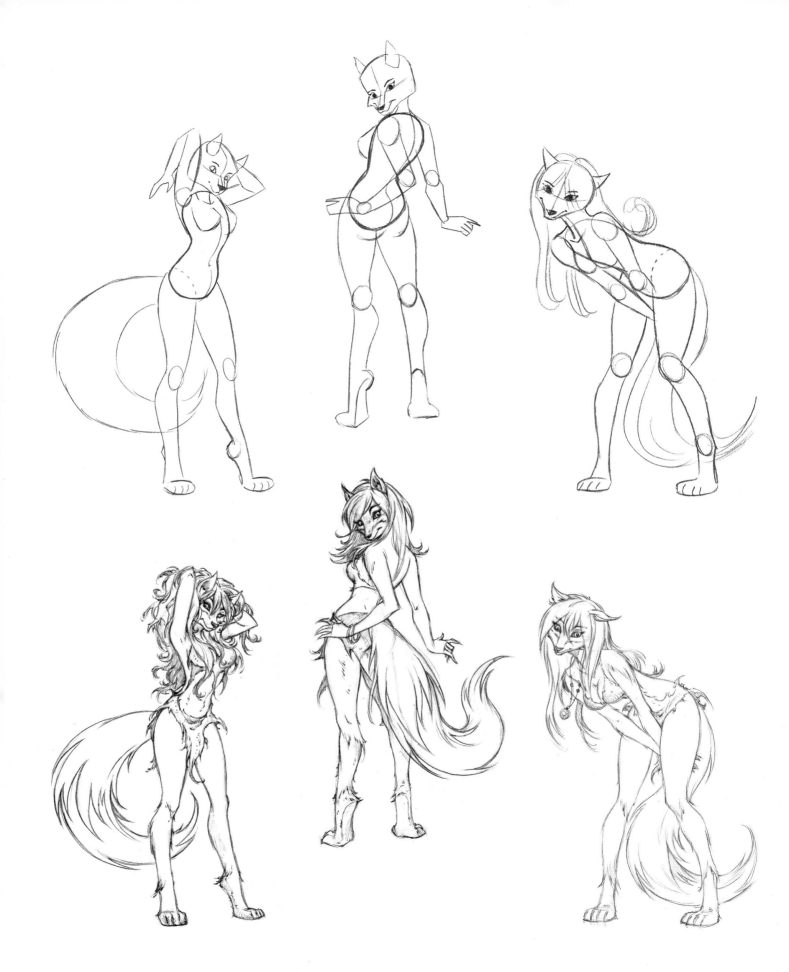

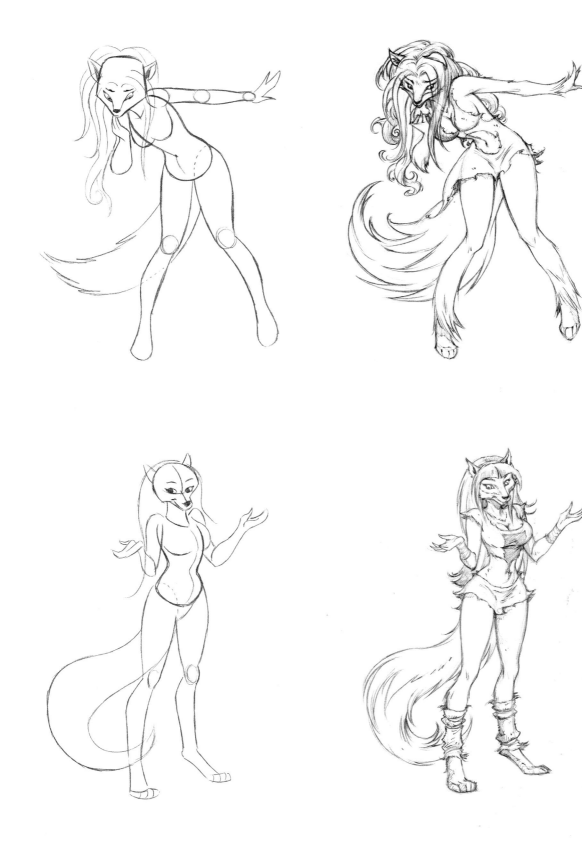

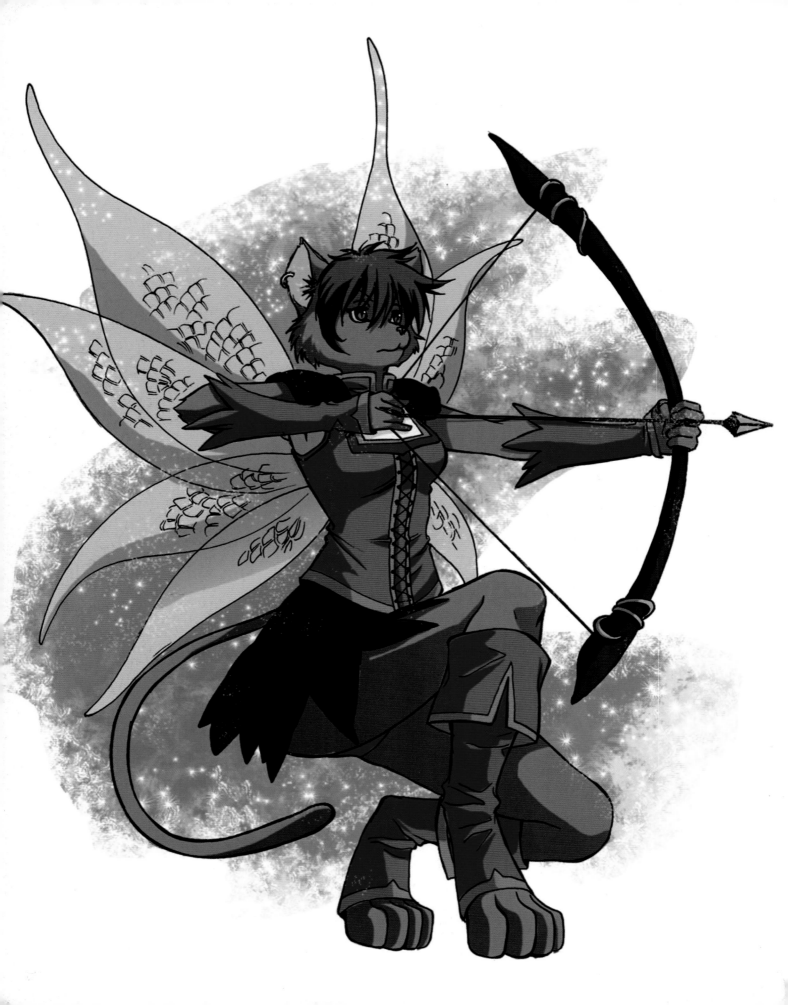

# chapter 4

# The Furry Wardrobe

Options . . . artists love to have them. It's what makes drawing and designing characters fun. So far, we've been working pretty hard at developing characters based on different head shapes and body types. Now we're going to let the costumes do some of the work for us.

A good costume is one that quickly identifies the period (time and place). Is it the past, present, or future? A good costume will also communicate if the character is casual or formal, rich or poor, friend or foe. In short, a well-designed costume takes a lot of the burden off your character design. It tells the story for you.

# SPORTY CLOTHING

Sporty clothing makes furries seem almost like humans. The odd thing about it is that the more you dress them to look like people, the weirder the result. Flashy and fanciful costumes have visual punch and therefore take some of the impact off the furry. But with casual attire, such as you see here, all of the emphasis is on the furry character. The character looks so human, and yet, it's so not. It's all very curious. Extremely so, eh?

When you outfit these furries head to toe in human clothing, you've got to be careful that you don't design them to look very human, too; otherwise, the combination may rob them of all their furriness. And all you'll be left with is a really weird-looking person, the type you see on the Eighth Avenue subway line in New York City at two in the morning.

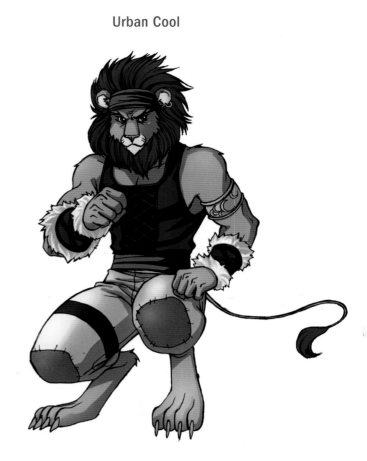

**Button-Down Shirt & Slacks**

**Zip-Up Jacket & Pants with Multiple Pockets**

**Sporty Top & Shorts**

### Short-Sleeve Shirt & Khaki Pants

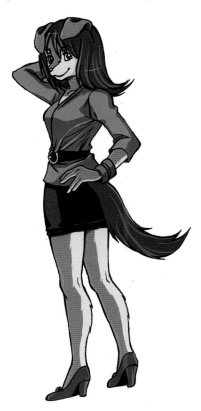

### Windbreaker & Jeans

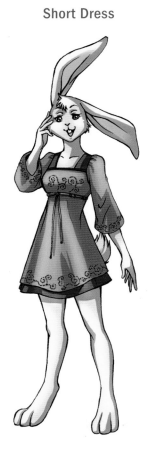

### Hooded Sweatshirt

### Blouse & Skirt
(Casual Business Attire)

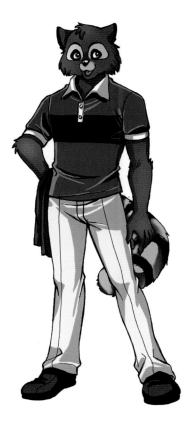

### Short Dress

### Work Clothes

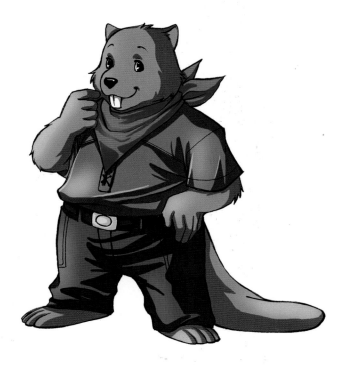

# VICTORIAN CLOTHING

You've all seen these types of costumes before, usually when your girl-friend drags you to one of those "dress-up," foreign period films that you'd never see if you had any will of your own. Well, now *you* can suggest one on your next date night, because you'll want to bring your sketch pad to do furry research into Victorian costume design. Will your girlfriend think you've suddenly gotten sensitive and cultured? Probably not.

On a more serious note, there is a time when researching costume-design ideas warrants bringing a sketch pad along with you. And that's when you go to a museum. Often, museums will have displays of actual Victorian clothing on mannequins. You can't find authentic stuff like that anywhere else. I've sketched those fashions at the Metropolitan Museum of Art and added them to my files. It makes great reference material.

Anyway, the Victorian-themed fantasy genre, sometimes called Steam Punk, is a popular and inclusive genre that can easily be adapted to include our furry friends. Furries look particularly good in Victorian clothing. Around the turn of the nineteenth century, some classical paintings and sculptures actually did portray animals, such as monkeys and dogs, dressed up in sophisticated clothing and as erudite thinkers. This, then, is one more step along that continuum.

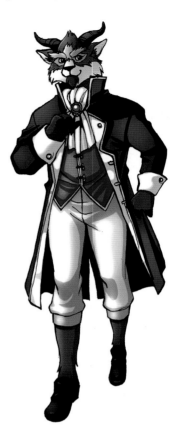

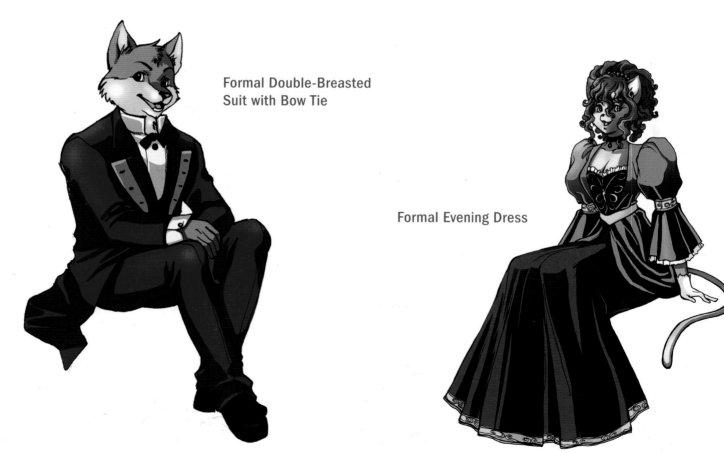

Formal Double-Breasted
Suit with Bow Tie

Formal Evening Dress

## Afternoon Dress with Parasol

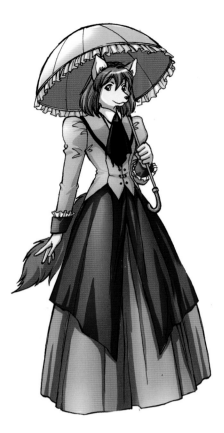

## Chauffeur's Uniform

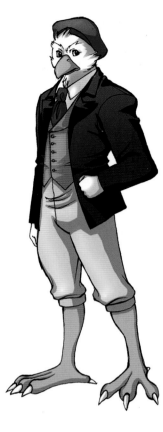

## Smoking Jacket & Top Hat

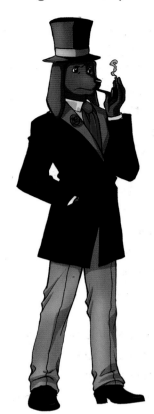

## Barmaid's Outfit

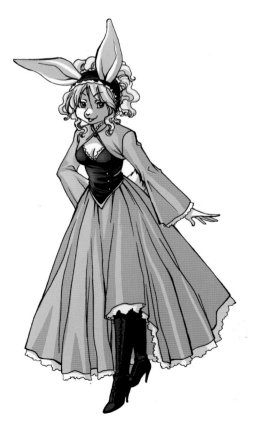

## Formal Overcoat, Scarf & Top Hat

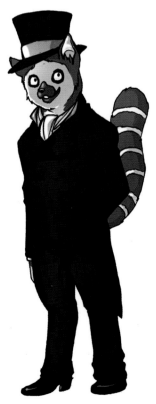

## Afternoon Dress & Hat

# FANTASY COSTUMES

Fantasy costumes are always popular. But have you ever asked yourself what the key influence is for fantasy outfits? It's not much discussed, but it will help to clarify in your own mind what you're aiming for. It's simple, really: *Fantasy costumes are a splashy take on medieval costumes.* It's really that simple.

Think about it. Many fantasy costumes have capes. That's medieval. They've got long boots and gloves. Medieval. They have obvious stitching on the body of the clothes. Medieval (peasant). They have hoods, sashes, staffs, and armor. All medieval motifs. In fact, some fantasy characters are so close to the medieval genre that they have created their own in-between genre: fantasy knights.

The fantasy genre isn't one single time period but an amalgamation of many different periods. For example, popular character types include a knight in armor (fourteenth century), a Friar Tuck type from the Robin Hood era (fifteenth century), a female Aztec warrior with spear (sixteenth century), and a pirate captain (seventeenth century)—all different periods in the fantasy genre.

Colorful clothing is one of the advancements that was made during the Middle Ages. Once the populace discovered how to make strong dye colors, they started to go crazy with them and used them on everything. What had once been a drab and dreary wardrobe became filled with bright and contrasting colors. It still didn't make up for all that plague, but at least it was cheery.

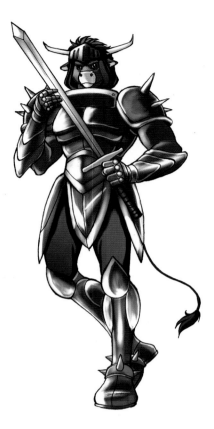

Armor & Sword

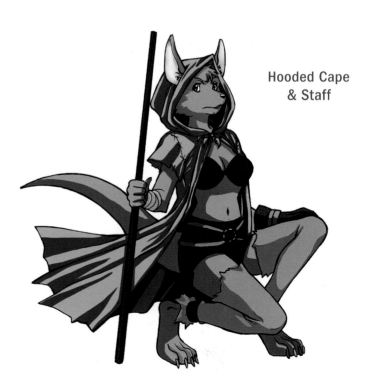

Hooded Cape
& Staff

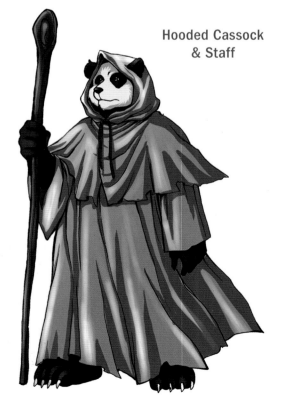

Hooded Cassock
& Staff

Asian Fighting Uniform

Samurai Outfit

Cape with Long Gloves
& Boots with Leggings

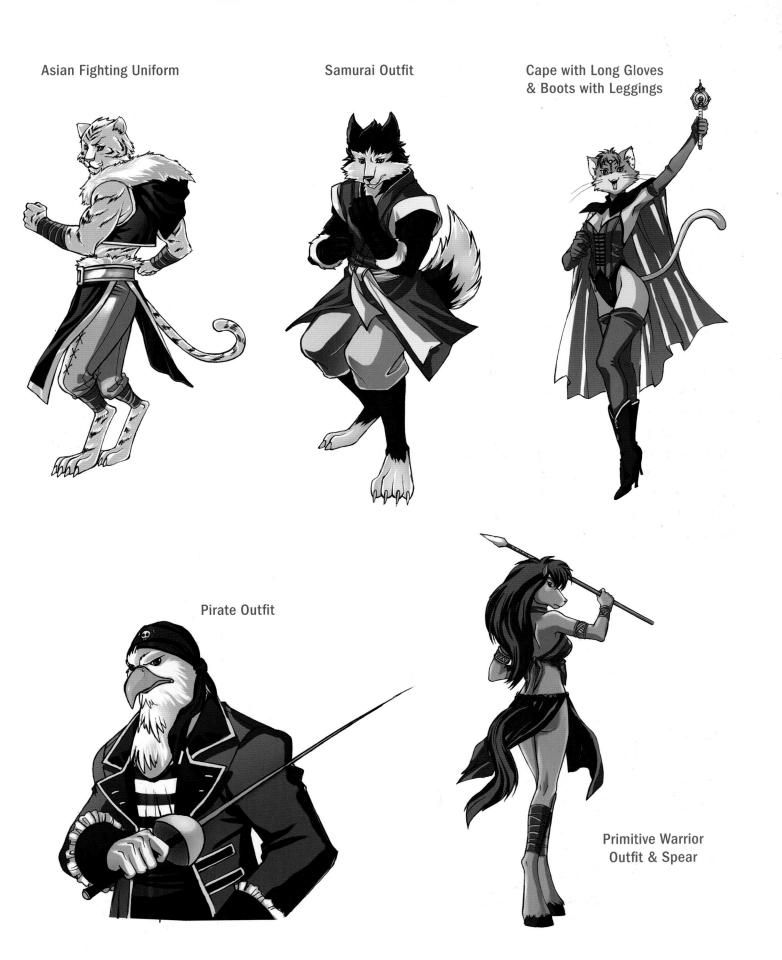

Pirate Outfit

Primitive Warrior
Outfit & Spear

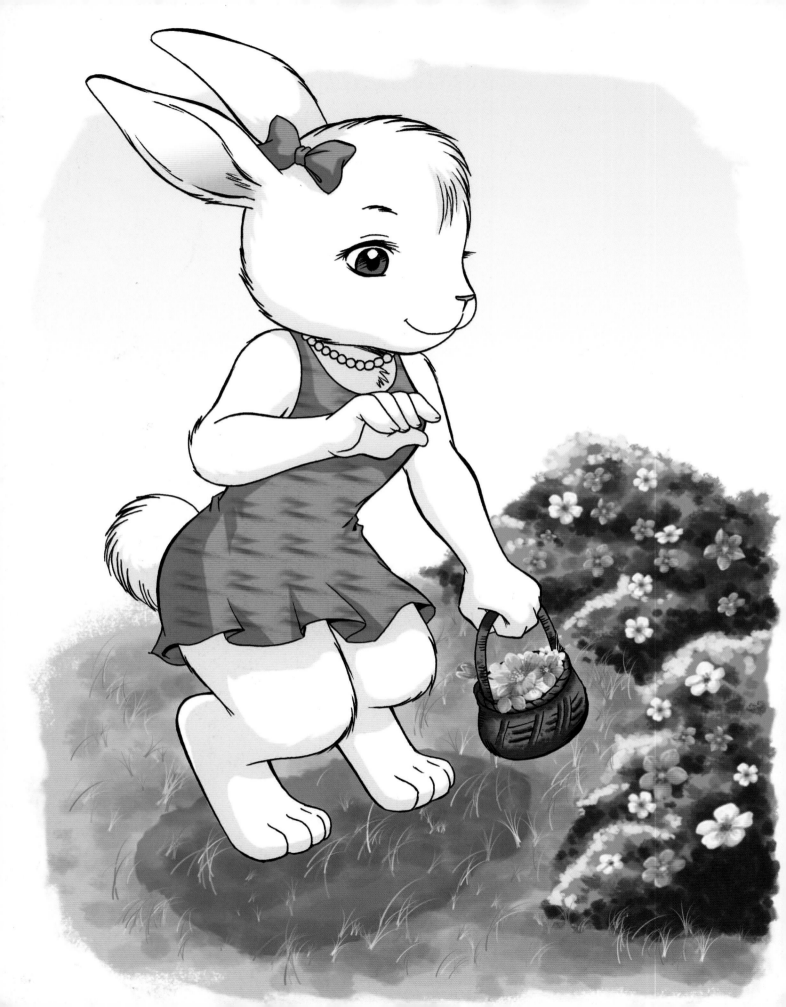

# chapter 5

# Cute & Charming Furries

Now we come to the different types of furries. We'll begin with cute and charming furries. Cute furries are not only popular but have the added bonus of being easy to draw. That's because their forms are based on rounded, simplified shapes that translate into a cute look. This chubby look helps hide their precise bone structure and results in a more forgiving image. The cute and charming furries also display innocent expressions, youthful features (big eyes, high foreheads, and small mouths), and slightly truncated proportions (small chest, pudgy tummy, and shortened stature).

Some of the first furries we're exposed to are in children's picture books—and those are, you guessed it, of the cute and charming variety. But popular animated movies have proven that supercute, animal-based characters remain popular past that early age. They also make good humorous characters.

# BEAVER

Let's start by taking a look at a classic, versatile cute guy—the furry-style beaver—to see what traits make him charming. Then we can extrapolate these and apply them to other characters, as well.

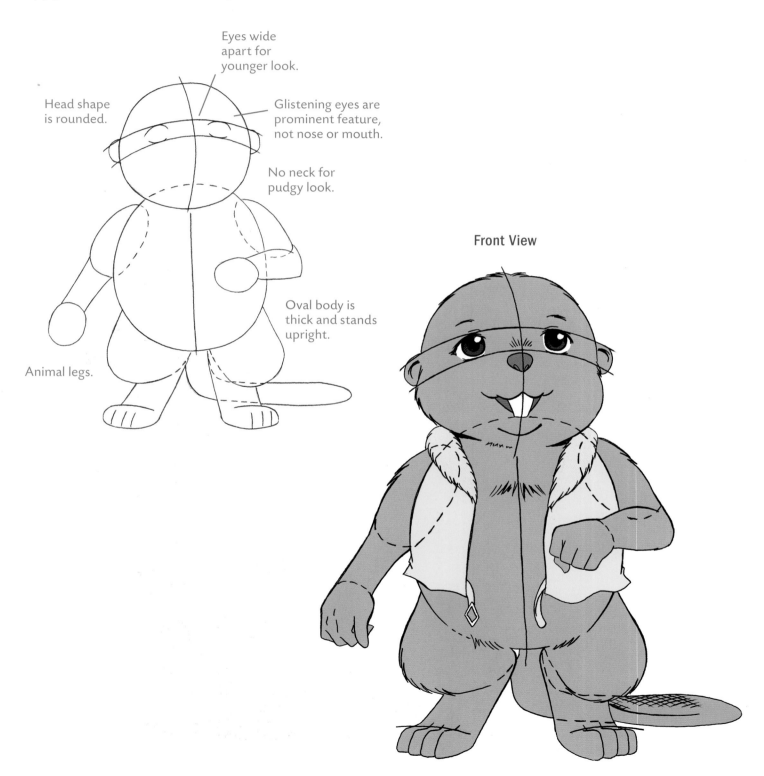

Eyes wide apart for younger look.

Head shape is rounded.

Glistening eyes are prominent feature, not nose or mouth.

No neck for pudgy look.

Oval body is thick and stands upright.

Animal legs.

**Front View**

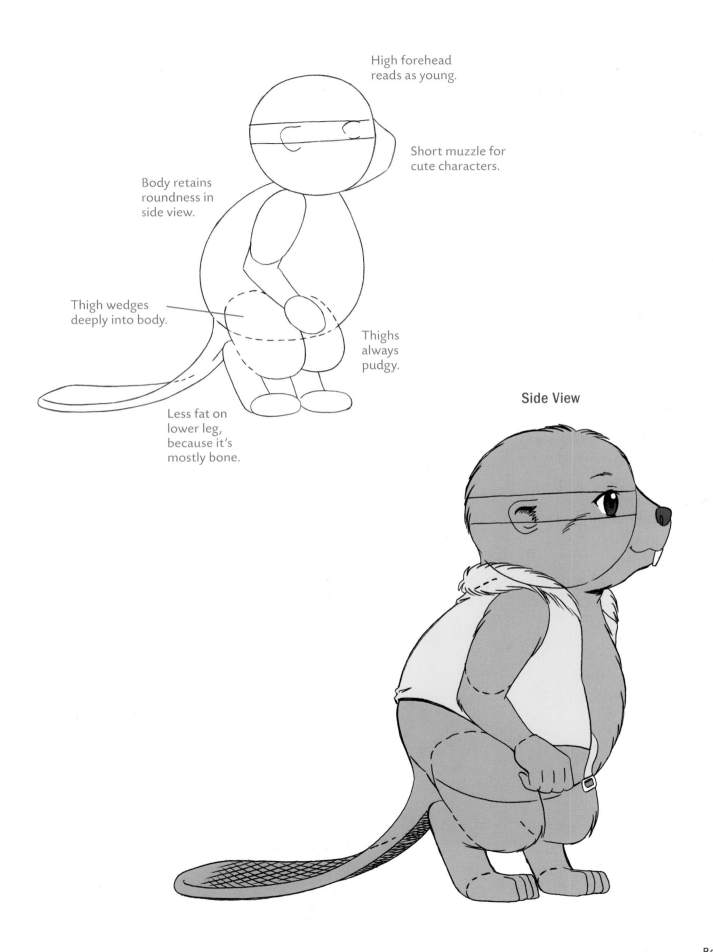

High forehead reads as young.

Short muzzle for cute characters.

Body retains roundness in side view.

Thigh wedges deeply into body.

Thighs always pudgy.

Less fat on lower leg, because it's mostly bone.

**Side View**

# BUNNY

The rabbit is one step more advanced than the beaver, because its body is based on two ovals connected together, rather than on only one oval. It's not as hefty as the beaver; still, all the same principles apply. Everything is kept round and pudgy and therefore soft, especially when you give the fur a brushed look.

The rabbit is drawn a little bottom heavy, as are most small woodland creatures. Having a slightly exaggerated rump gives it a toddlerish type of outline. Like all cute characters, the rabbit also has a large head compared to the overall size of its body. That big-headed look is an important proportion to keep on all cute characters.

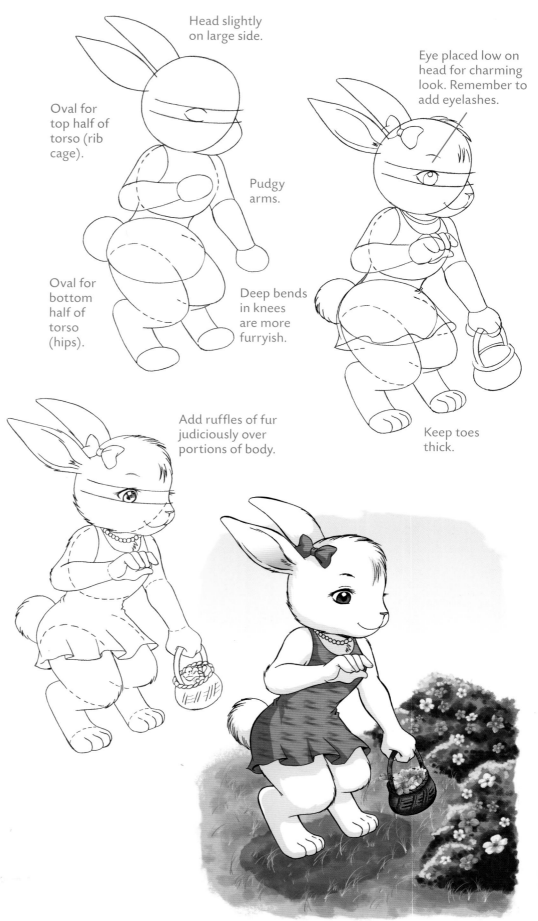

Head slightly on large side.

Oval for top half of torso (rib cage).

Oval for bottom half of torso (hips).

Pudgy arms.

Deep bends in knees are more furryish.

Eye placed low on head for charming look. Remember to add eyelashes.

Add ruffles of fur judiciously over portions of body.

Keep toes thick.

## WHITE ANIMALS

Even when a character's color is white, like this bunny, its fur is highlighted with a color. In this case, that color is a light bluish-gray. If there's no highlight, you run the risk that the character will simply look empty, as if you've forgotten to color it altogether. A little gentle highlighting around the outline of the body softens the look.

# FAWN

Hoofed animals present a special challenge, because they're generally lithe and sleek—not pudgy—and have slender limbs. How, then, are we to transform them into cute furries?

One of the best techniques is to draw the character in human, boyhood clothes. This immediately brings forth associations of springtime and childhood. Work to keep the muzzle only as large as it needs to be and to minimize the size of the nose. Give the eyes an elegant, sparkling look, and soften the outline of the head by rounding it off.

Note how the body, though not the classic "cute" body shape, is nonetheless pleasing. That's because it has been drawn to mimic the proportions of a human boy's body. Round off the shoulders and fatten up the thighs a bit. But leave the hind-leg hooves authentic-looking for a furry finish.

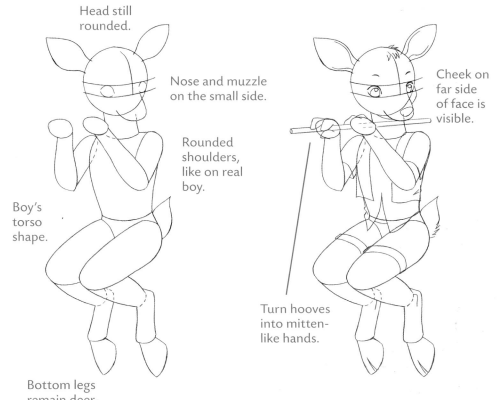

Head still rounded.

Nose and muzzle on the small side.

Rounded shoulders, like on real boy.

Boy's torso shape.

Bottom legs remain deer-like, with split hooves.

Cheek on far side of face is visible.

Turn hooves into mitten-like hands.

## FURRY TIP

Give your furries human things to do, like playing instruments or engaging in sports or going to the movies. This requires drawing the furry in human poses, which is what you want. It helps the pose if you give your furry a reason to act human—for instance, practicing the flute.

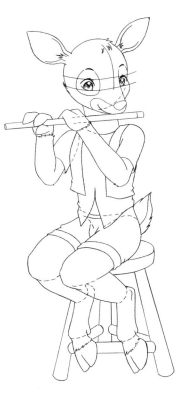

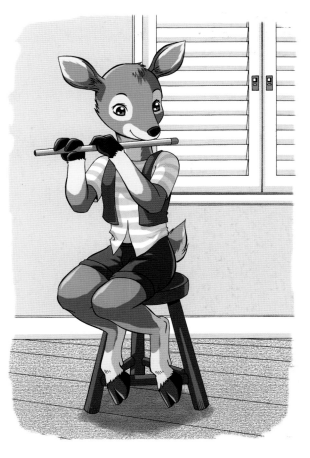

# HAMSTER

Here's a supereasy furry to draw. This hamster's body is one big oval—and not much else—wrapped in fur. The head, too, is simple if you start with an oval. Then just add a little "bump-out" to the outer cheek (as in the first drawing below), and you'll have the basic structure of the head in place. Hamsters make very popular characters types. They're even the stars of movies.

When you clothe your charming furry, you don't need to do a complete job, with shirt, pants, socks, and shoes. Often, just a shirt is enough, or just pants alone will do it. It's the suggestion of clothes that you want, not a head-to-toe wardrobe.

**FURRY ENVIRONMENTS**

Where do cute, little forest furries live? In cute, little tree houses in enchanted, elfinlike communities where the wood is knobby and everything has a slightly precious, old-fashioned look to it. Everything should be cute and chunky and slightly miniature. Outside the tree house, there are woodlands, with flowers, streams, trees, and hills.

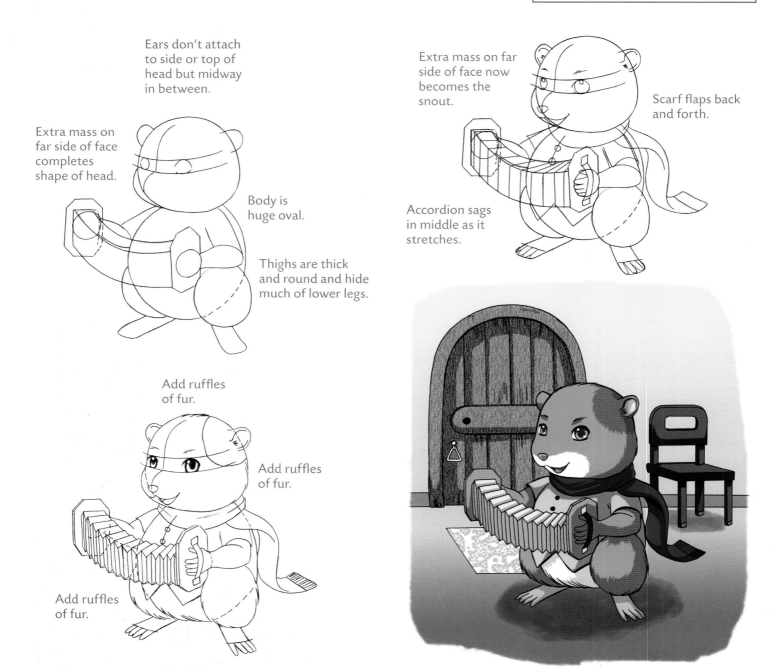

Ears don't attach to side or top of head but midway in between.

Extra mass on far side of face completes shape of head.

Body is huge oval.

Thighs are thick and round and hide much of lower legs.

Extra mass on far side of face now becomes the snout.

Scarf flaps back and forth.

Accordion sags in middle as it stretches.

Add ruffles of fur.

Add ruffles of fur.

Add ruffles of fur.

# RACCOON

It's night and time for all the cute little furries to go beddy-bye. Some are dragging their favorite blankets upstairs with them. But our raccoon friend is carrying his comfy pillow tucked under his arm. How can you out-cute that one?

Raccoons are often referred to as bandits because of their eye band—and their mischievous personalities! But as you can see from the finished illustration, we can counter any preconceived notion of negative traits by simply giving the character an abundance of charming proportions and features and turning him into a charmer. Voilà! Cute raccoon!

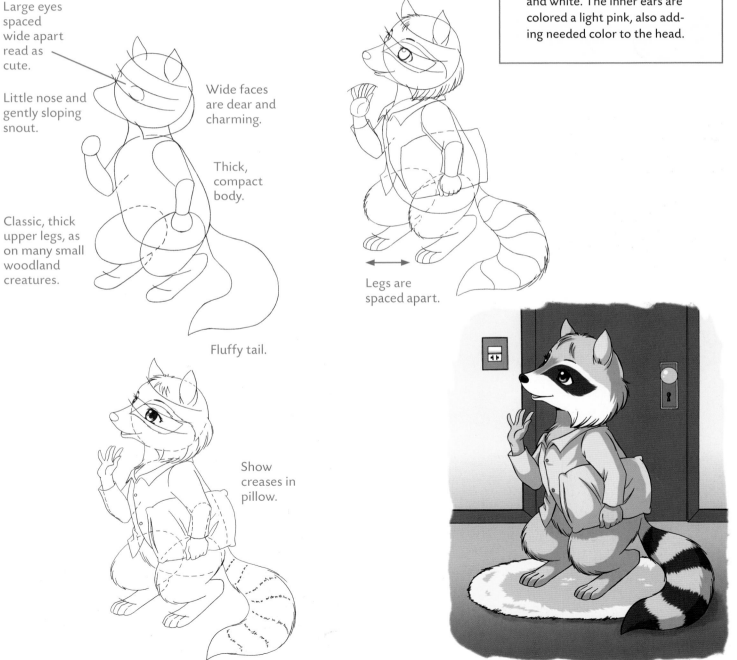

COLOR TIP

With a nighttime scene, you don't want a lot of loud colors fighting for the eye's attention. Therefore, pale yellow, powder blue, and a palette of warm grays work well to set the scene. Notice that the eye is actually blue and not just black. This little extra color helps to brighten up the face and works well on characters that are mainly black and white. The inner ears are colored a light pink, also adding needed color to the head.

Large eyes spaced wide apart read as cute.

Little nose and gently sloping snout.

Classic, thick upper legs, as on many small woodland creatures.

Wide faces are dear and charming.

Thick, compact body.

Legs are spaced apart.

Fluffy tail.

Show creases in pillow.

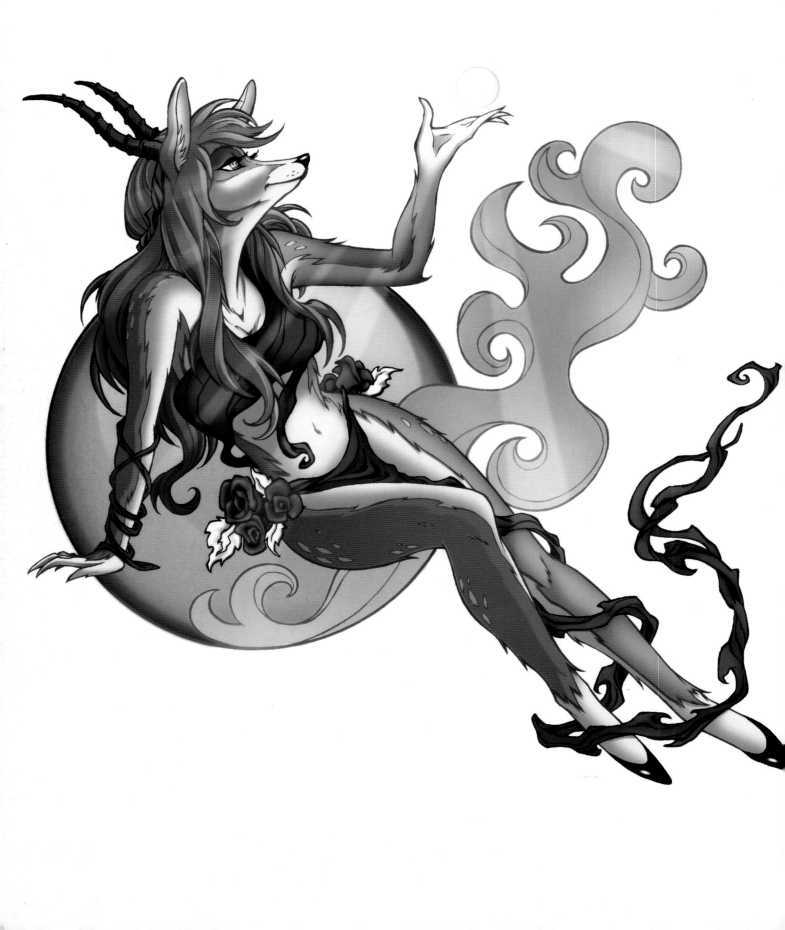

# chapter 6

# Glamorous Furries

We like to pamper our animals, admit it. Cats get the Park Avenue treatment. Horses are brushed to look their best and trotted around the ring. The little bichon frise pup is kept in style by the rich and chic. Yes, we make animals the stars of the show, whether it's in a contest or in a movie. So it should come as no surprise that we also like to glamorize furries.

As important as character design is, body language is equally important in communicating glamour. Therefore, this section will feature furries in the classic poses that have helped catapult them into the stratosphere of glamour and beauty.

# DEER

Deer are popular among furry fans because of their natural beauty. On real deer, the limbs taper gracefully, just as they do on furries.

The furry deer's glamorous pose is conveyed through the angles of the shoulders and hips and the way the head is tilted. Half reclining, with her chin down on her chest, this furry shows a playfully flirtatious mood. Note, too, that furries have spent a good amount of time in front of the mirror, applying eyeliner.

*Start off with a simplified stick figure that has a rib cage and a pelvis (the hip section).*

*To finish the image, sketch the details: the expression, the ruffled fur, the hair, and the like.*

*Flesh out the frame, still keeping the stick figure skeleton inside.*

Now you come to the clean-up step. No, I don't mean that kind of clean-up, where your mother nags you until you put away all the junk in your room. This is about cleaning up your rough drawing. It's much more fun, and you don't have to worry about finding cheese chips under your bed.

To clean up your drawing, you create a clean copy from your previous rough draft. How do you do that? One way is to ink over your original drawing, and when it dries, erase the underlying pencil. Another way—and the method I use—is to put the rough drawing on a light box, place a clean piece of paper over it, and trace over it to produce a clean duplicate. Yet another way is to do the initial drawing with a non-repro-blue pencil, which is a special color that won't show up in a scan. Then you simply draw over it in ink, and program the scanner not to pick up the non-repro blue.

Two colors that complement each other (and are popular as a theme in cartoons and comics) are orange and green. Variations of this color combo are repeated often throughout this book.

# FOX

Although this fox is leaning back, all her fur and her tail are blown forward by the wind. Why? Is it really breezy today in Furryland? Here's a hint: When wind blows against the direction in which a character is leaning, it creates a romantic figure. This figure is leaning right, so the wind blows left. Hence, a cool look. This semireclining pose is also a classic glamour pose.

*The body leans back at a 45-degree angle. The shoulders are raised because the arms are propping up the body.*

*The placement of the legs and tail creates a three-dimensional effect, due to the layering of the elements. There's one foot in the foreground, then the tail in the middle ground, then the other foot behind it in the background. That's three layers, which together give the illusion of roundness. Seek out ways to layer your drawings to give them a solid look.*

*Other details to note: The nose points downward. On the near leg, the knee lines up with the toes. And there are lots of ruffles of fur on this one.*

*Use sweeping lines to ensure a graceful quality.*

*There's that orange-and-green color combo again—but in different shades of the two hues. Still works well, no matter what shade of orange or green you match together. Also, white-haired characters are on the cutting edge of today's comic art, whether they're furries or people. It's a good stylistic choice for your characters.*

# GAZELLE

Now we have a semireclining furry, but with only one arm propping her up and with her head held high instead of tilted down (as we had with the fox). This is a very feminine look, made even more so by her knees touching each other. The spine is gently curved, not straight. Both shoulders are raised. And the "feet" point down, giving her legs a sleek look. Make sure you emphasize the contrast between the narrow waist and the wide hips.

This gazelle has some tricks up her fur, as she conjures a bit of magic. It's ultra-important to get the shape of the horns correct, as this is the main item that distinguishes her from other hoofed animals in Furryland. And note that the vegetarian animals are usually depicted as peaceful furry types. The predators are the warriors. Humans are personae non grata.

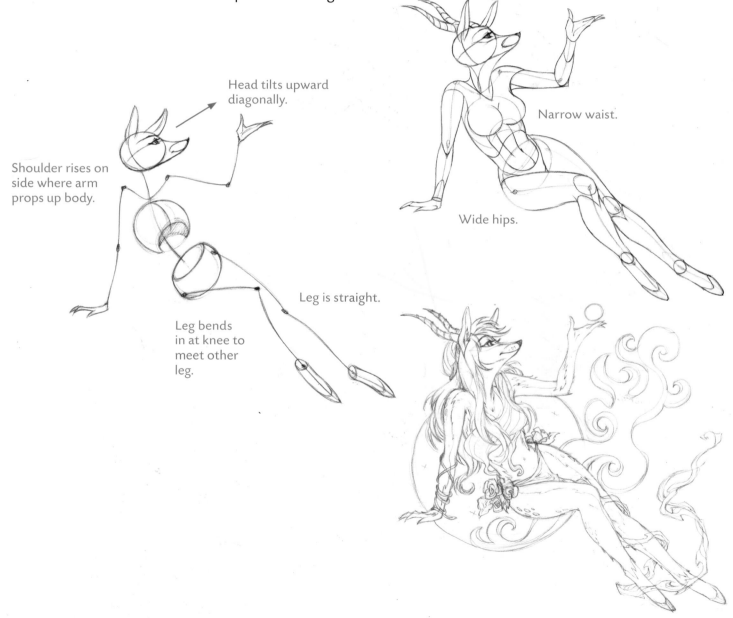

Head tilts upward diagonally.

Shoulder rises on side where arm props up body.

Narrow waist.

Wide hips.

Leg is straight.

Leg bends in at knee to meet other leg.

Heavy, black mascara on eyelashes.

Horns have great spiral markings on them.

Curls and swirls create magical effect.

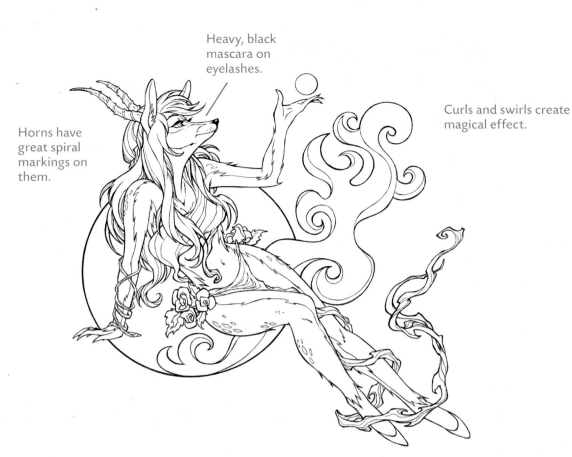

*Look! Another green-and-orange color combo—what a stunner! Hey, if it works, stick with it. But there's also another famous comic book color combo in use here: violet and pink. That's always a winner, and it's used here for a soft background environment. Since it's muted, it doesn't over-power the character in the fore-ground, and this should always be a consideration when choosing background colors.*

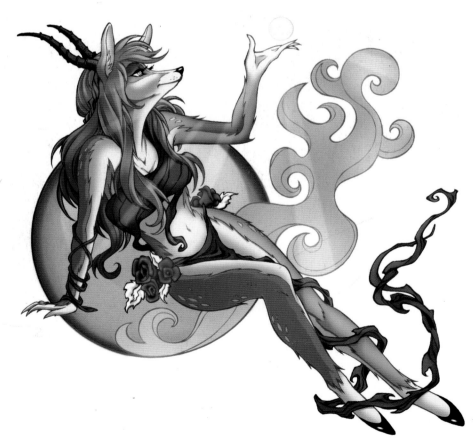

# LEOPARD

Her torso is long and slinky and drawn along an arc (the arc of her spine). As you can see, the tail is an extension of the spine and curls upward attractively. The neck is also an extension of the spine. The spine is one long line that dictates the thrust of the entire pose.

The leopard's head is slightly small for its body. That's one of the things that makes a leopard different from a lion—that and the spots. And for a humanizing effect, this furry has human hair. It's a bold move, so you have to be sure the hairstyle makes a statement when you do it.

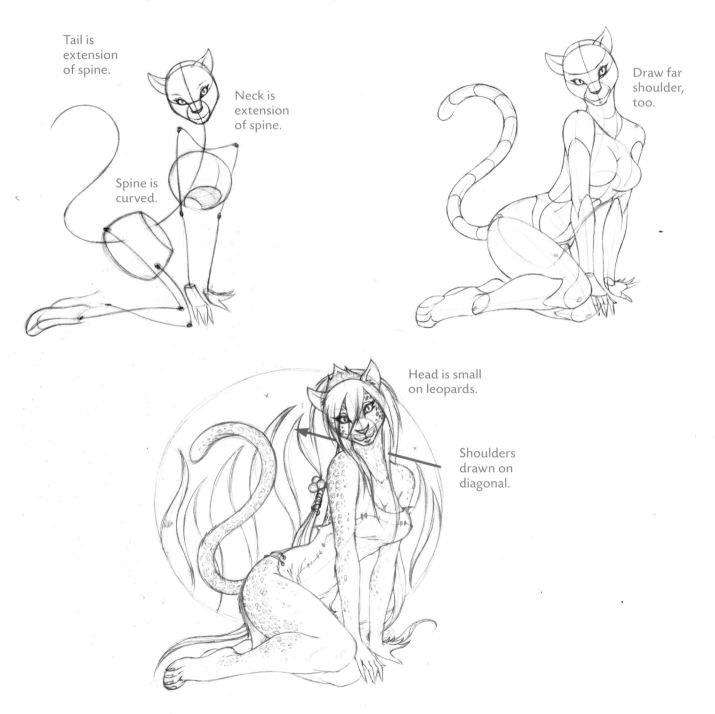

Tail is extension of spine.

Neck is extension of spine.

Spine is curved.

Draw far shoulder, too.

Head is small on leopards.

Shoulders drawn on diagonal.

Tail forms shape of
a question mark.

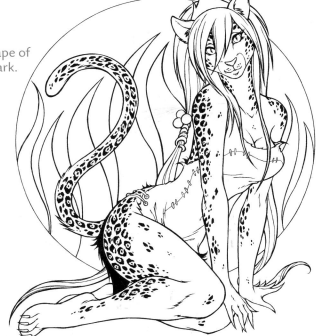

Draw spots on the outer parts of the limbs,
leaving the inner parts of the body clean of
markings. Too many spots and the character
looks cluttered.

As far as color goes, we've turned this ani-
mal into a nocturnal hunter merely by adding
a purple-and-black background. There's no
need to shade the main character with these
colors, only the space surrounding her.

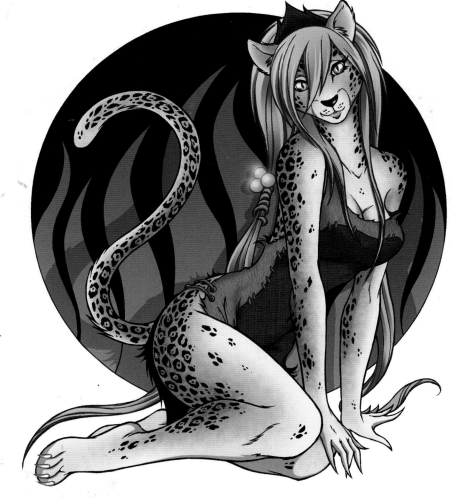

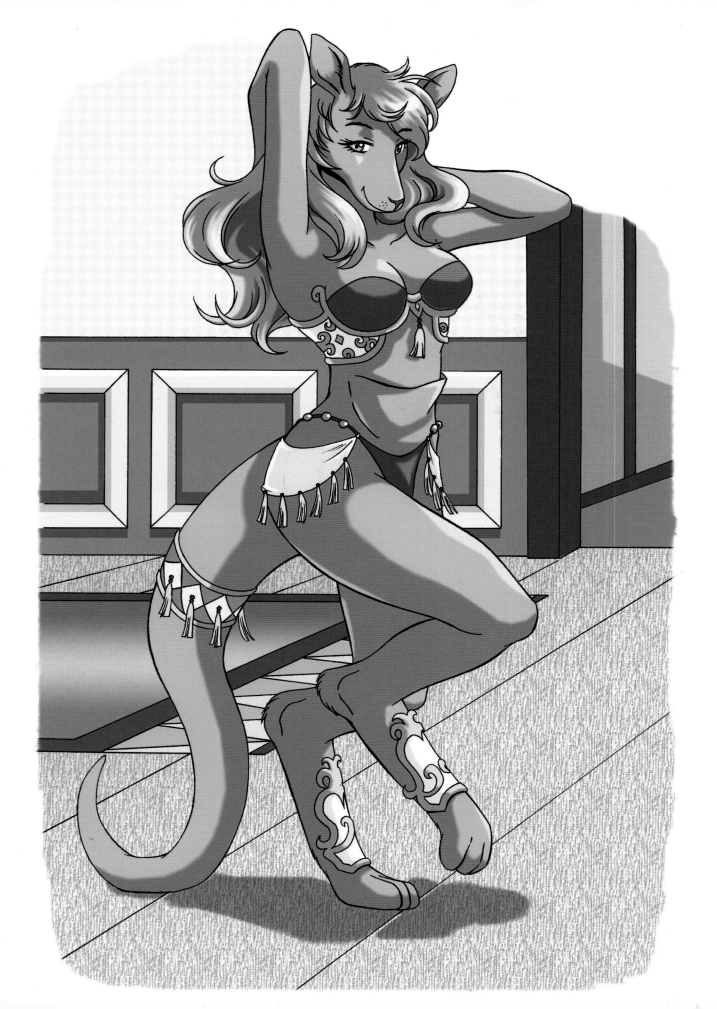

# Furries of the Fantasy Realm

The fantasy world has given birth to a multitude of popular furry characters. These strangely alluring furries live in a parallel time and place, a place where man does not exist but hybrid creatures do. Fantasy furries inhabit primitive civilizations that also exhibit mystical and surreal elements. Every animal has its own role to play. Predatory animals are often cast as fighters. Hoofed animals are often the defenders. Small woodland creatures are quick and elusive and are sometimes cast as comic relief. Any heavily feminized animal can be depicted as a seductress or a fighter, as well.

# TIGER WARRIOR

Most fantasy fighters carry weapons. For example, this tiger carries the long blade, with which he is an expert. The long blade was the weapon of choice among the samurai class. So it's no coincidence that he wears a headband, which gives him a passing resemblance to a Japanese warrior.

To make the build look impressive, the shoulders are drawn to look like honeydew melons. But even more important, the tiger's head is drawn on the small side, which makes the physique stand out by contrast. Remember this principle: If you want to highlight one area, contrast it with an adjacent area. Small head against big body results in an impressive build.

Posture is an important element of your character's body language—perhaps the most important. Even though this tiger is kneeling, his upper body leans slightly forward. This shows him to be assertive and unafraid—a true leader.

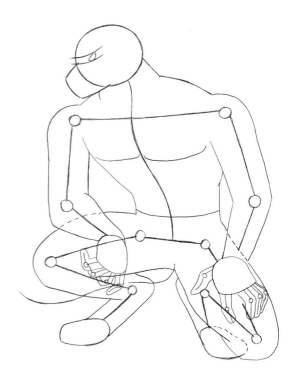

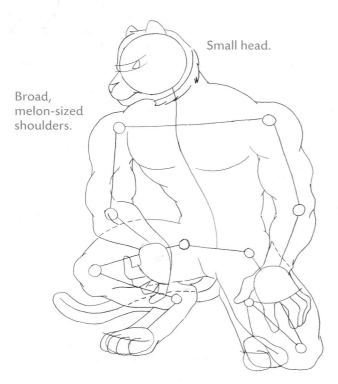

Small head.

Broad, melon-sized shoulders.

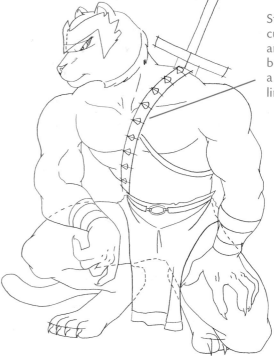

Strap curves around body; not a straight line!

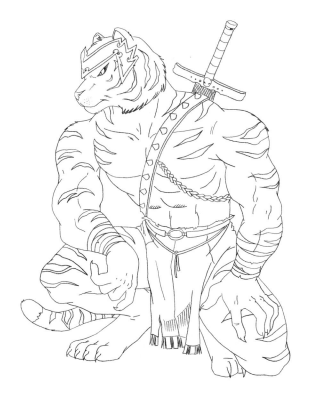

*Make sure the ground isn't the same color as the fur; otherwise, they'll start to blur together and lose their sharpness.*

Stripes aren't too thick or too long.

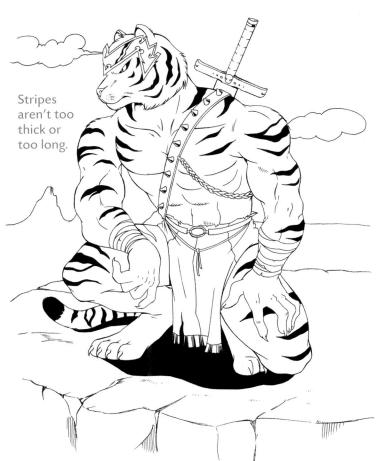

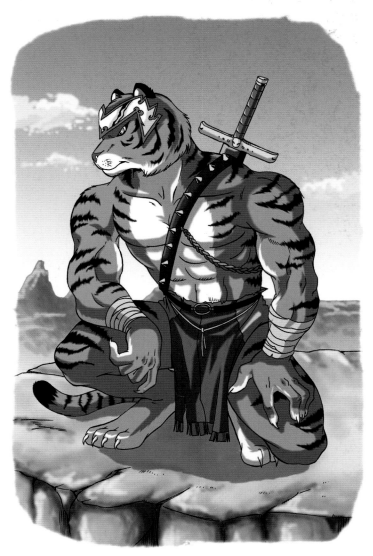

# POLAR BEAR SENTRY

There are many species of brown bears, but there's only one white bear—the polar bear—and this uniqueness makes it magical and mysterious. The polar bear is also built slightly differently from all other bears. Its head, in profile, is decidedly sleeker than that of other bear species. It has a long body, with pronounced black claws that contrast against its white fur coat.

This character has a facial tattoo. That pushes the character deeper into the fantasy genre. If you felt the need to go further, you could also add a horn to the forehead. Further still? Wings.

Like any brute character, this guy is mostly upper body with short legs. What's that big mallet for? When he gets cranky, he likes to be able to express his emotions rather than keep them bottled up in an unhealthy way. This is why you should never give a polar bear a self-help book.

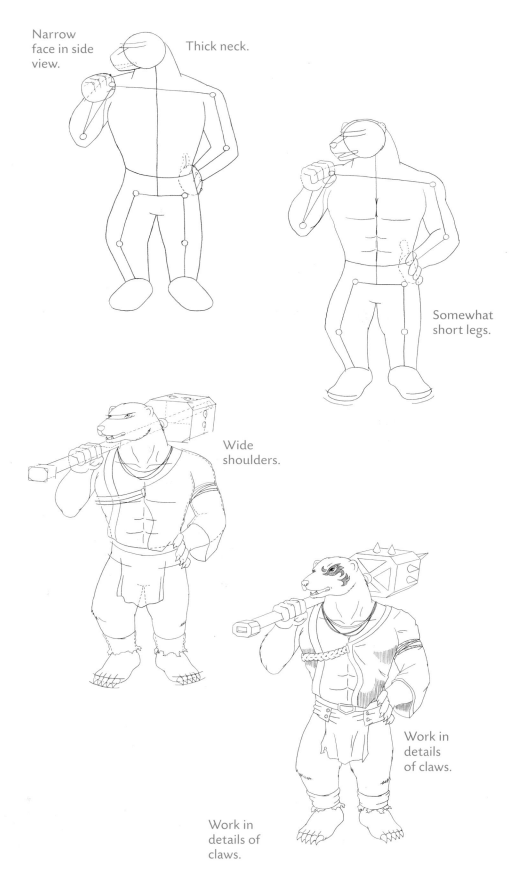

Narrow face in side view.

Thick neck.

Somewhat short legs.

Wide shoulders.

Work in details of claws.

Work in details of claws.

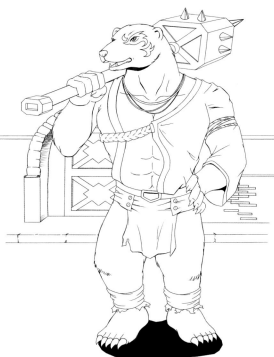

## SNOUT DETAILS

**Polar Bear**
Both the snout and forehead are narrow and streamlined on the polar bear.

**Brown Bear**
Brown bears and other bears have a narrow snout but a square forehead.

*We often think of the medieval mace as a spiked ball on a chain, but the spiked hammer was a popular type of mace, as well. It didn't have any moving parts, so no assembly was required. You just opened up the gift box, and you could start bashing heads right away.*

*The white of the polar bear fur really pops against the darker background colors. Although the fur is white, note that some gray and faint blue are added to the coat to bring out the highlights. This makes the furry look three-dimensional.*

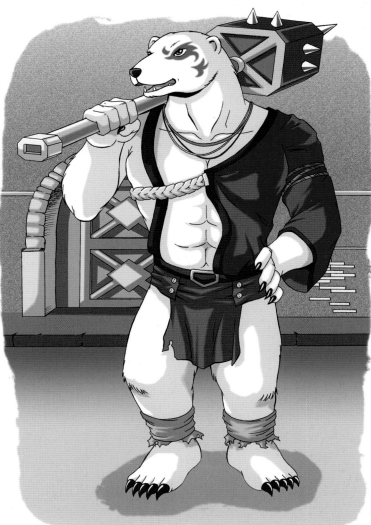

# EAGLE ARCHER

People don't generally realize just how big and majestic eagles are. The eagle's considerable size and wingspan allow you to turn it into a successful furry without destroying the animal's integrity. Layer the feathers that emanate from the human-style arms, but keep the legs pure eagle from the knees down.

Because of the eagle's hunting nature, the costume mimics a military-style one, with army fatigues for pants. He cuts a great profile, with a sharp, hooked beak; a rounded head; and a widening neck. You'd better be ready to get into shape if you signed up to be in boot camp with this drill sergeant. There will be no time for resting and no water breaks.

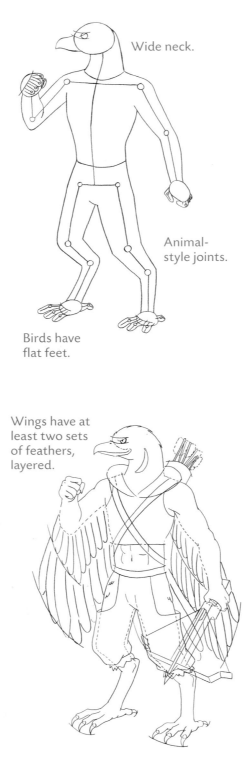

Wide neck.

Animal-style joints.

Birds have flat feet.

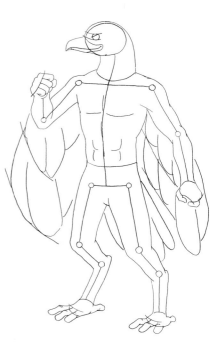

Wings have at least two sets of feathers, layered.

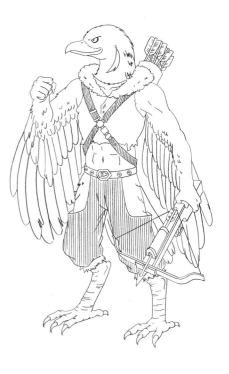

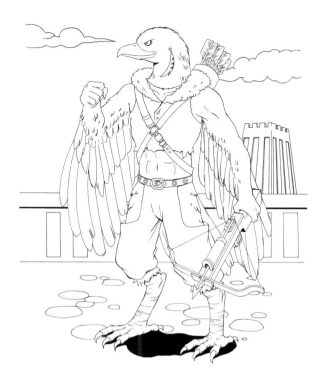

Note how thick the eagle's legs are. Those talons on its feet are formidable weapons. And the shading in the pants and other areas has been removed here in the inked version.

## EYE DETAIL

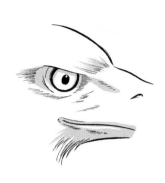

The eye is very important, because it's a distinctive eagle feature. It should be small, round, and deeply set (as indicated by surrounding shadows), with a tiny pupil at the center.

The eye also always has a razor-sharp, ultrathin eyebrow cutting across it, giving the bird a severe look.

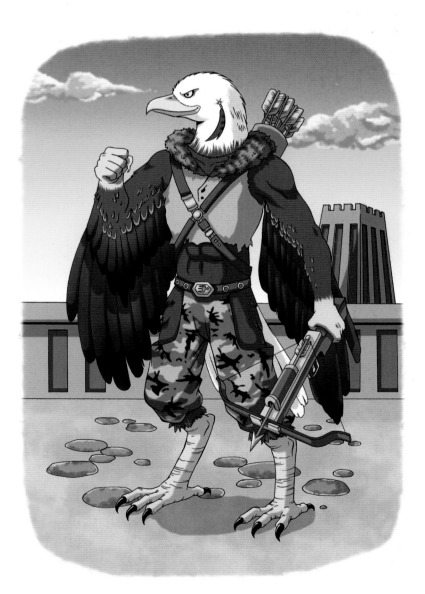

In the wild, eagles have brown and white feathers, a yellow beak, and yellow claws, just as our furry eagle character has here. Therefore, this furry eagle's color scheme provides a continuity of character; this is needed to remind us that it is, in fact, an eagle, since so much of the original eagle's form has been modified, as far as the posture, arms, hands, and even the addition of clothing goes.

# BADGER TEMPLE GUARDIAN

Badgers are small, but they can also be fierce. This one is a guardian of a sacred temple. Notice how perspective is used to create greater impact in this picture: The blade at the top of the spear, which is nearer to us, is drawn larger than the bottom of the spear, which is farther away from us. The spear is also drawn at an angle, instead of straight up and down, because diagonal lines are more interesting than straight verticals or straight horizontals.

Although this female badger's physique isn't as muscular as the male of the species, her contours, though reduced, should nonetheless remain apparent on the outline of her figure. And note that, generally speaking, the closer to the ground an animal stands on all fours (in real life), the deeper its hind legs bend when it adopts an upright, human posture as a furry. This badger, therefore, stands with her knees deeply bent.

Knees bend deeply.

Short characters have truncated waistlines.

Muscular arm contours.

Blade widens toward top.

Spear narrows at bottom.

*Note how the character's hair falls behind the arm and how the tail can be partially seen between the legs. Paying attention to minor details is what adds three-dimensionality and raises the level of your drawing.*

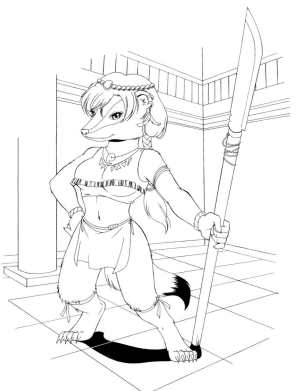

*Better not make this just black and white, or it'll look like a skunk!*

**BADGER PAW DETAILS**

Top

Underside

*Badgers have a lot of black and white fur on them. But that color scheme can be mistaken for a skunk, so change the white fur to a cream color or a pale yellow.*

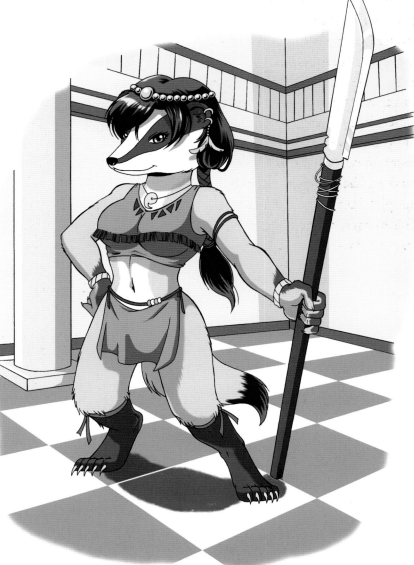

# SNOW LEOPARD WARRIOR

This snow leopard holds two swords, only one of which is gigantic. So why doesn't the pose feel lopsided, tilting toward the side with the much bigger sword? For the answer, look how the pose was designed. The side with the small sword also has the tail on it. The side with the big sword shows no tail. Overall, both sides are therefore "mass equivalent." It's an artist's trick to make you subconsciously comfortable with the pose. Try it.

Deep curve (arch) in small of back.

Deep bend.

Locked, weight-bearing leg.

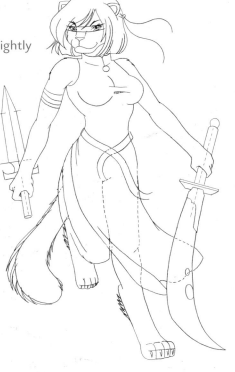

Shoulders slightly raised, for attitude.

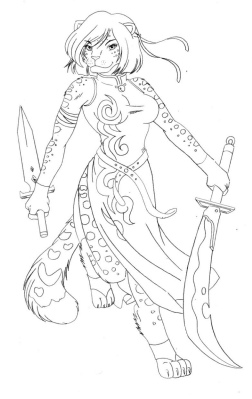

*Once you've got all the challenging parts done, you're ready for the fun part: decorating your character with markings, clothes, ribbons, and weapons.*

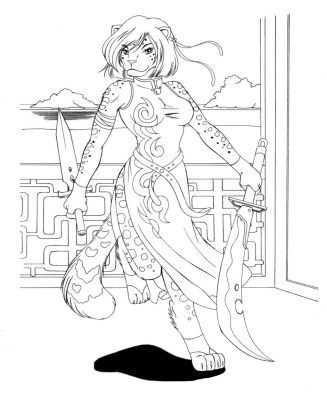

Note that the top half of the robe fits tightly, but the bottom half, after the belt, flows freely.

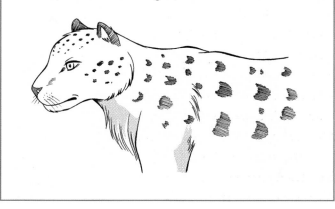

### REALISTIC SNOW LEOPARD

This is a beautiful animal, combining grace with strength in equal proportions: small, sleek head and big chest.

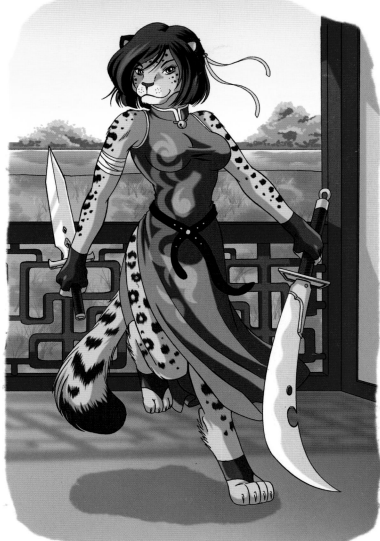

That robe is a celestial blue, made even more dreamy by the addition of the pink pattern running down the side. That pink theme is repeated in her hair. The swords cannot be golden because her coat is golden, and there would be no contrast. Best to make the blades silver by adding gray and white together.

# LIONESS GODDESS

You can imbue your furry character with a free spirit by making everything about her look windblown, from her hair to her clothing to her tail. It should all be flowing gently in the same general direction. The white outfit gives her a Greek-goddess type of presence.

Lionesses, as opposed to lions, have no mane. But she wouldn't look nearly as glamorous or feminine without a head of fantasy hair. When you give her a big hairstyle, you've got to be sure that it doesn't come off looking like a lion's mane, which would change her gender to male. By drawing long strands of hair that gently twist in the breeze—but don't appear under her chin—you create a feminine look that's unmistakably different from a male lion's mane. The color is also important. (A real lion's mane is a darker color than its coat.) Here it's a luxurious red—something you'll only find in the world of fantasy furries.

Body moves in this direction.

Push-off leg.

Body moves in one direction; hair and tail move in the other.

*The lioness looks back, even though she's moving forward. This mixing of directions gives a pose dynamic energy.*

*There's no need to draw head-to-toe full-length robes when abbreviated versions do just as well.*

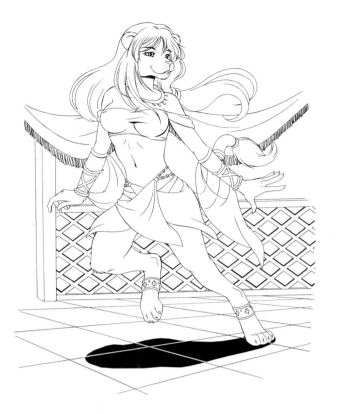

This demonstrates the anatomy of the semihuman lion hind leg and its three major bone sections.

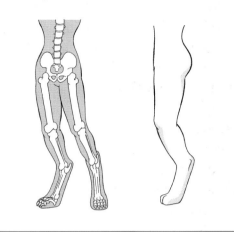

This is the type of pose that professional artists like to explore: the "moment frozen in time" in-between pose. It takes place in the middle of an action. The character is typically drawn to appear poised and graceful, with not a hair out of place. It's a good look.

There's no background behind the fence, almost as if this building were high up in the sky above the clouds, in a Mount Olympus–type setting.

# GIRAFFE OF ENCHANTMENT

Just one small change on an animal, such as adjusting the mane to include long pigtails, and the result is a whimsical creation. When you're looking for changes to make in your character, consider things that will affect the reader's overall impression. Instead of making tiny adjustments that only add slight accents, think boldly. You need one or two *big ideas* for each character design. For example, with this giraffe, the smaller ideas are the scarf around the neck, the belt around the chest, and the ankle guards. They're cute but don't amount to much in the overall scheme of things. The braided hair, however, is another story. That's a prominent addition to the character design. It's unique, unexpected, and transformative.

Giraffes always have huge chest area (rib cage).

Combine huge chest with small hips.

Long, thin legs.

Small (or no) chin for appealing, peaceful-looking, fantasy giraffes.

Pigtails wind around to front of chest.

Tail is slightly longer than normal for whimsical look.

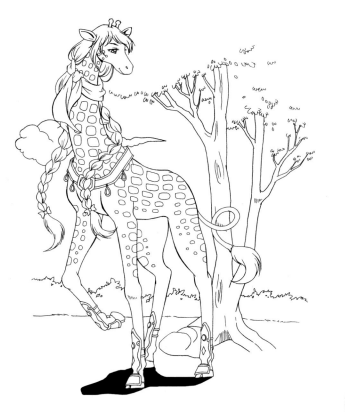

The horizon line indicates that the ground has been placed low to show the giraffe against a huge sky, which makes her look taller. Make sure you've got the scale of the drawing correct: She should be as tall as the upper branches of the trees.

## GIRAFFE DETAILS

Note the bulbous joint just above the hooves, and maintain a good amount of space between the patches of brown.

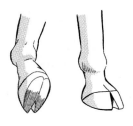

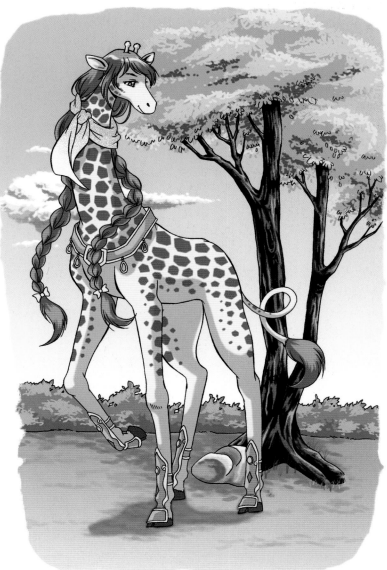

*Furries that remain standing on four legs look like real animals, which makes color all the more important to their character design. It can bring the furry into a fantasy realm. In this case, the pink hair does the trick.*

# IMPALA WIZARD

The wizard is drawn wearing a long robe or cape with a high collar and carrying a magical staff with an amulet on top. But he doesn't wear the typical wizard-style conical hat because, well, as you can see, he'd have a heck of a time getting it to fit over his antlers—and an even harder time getting it off.

Rather than an old and creaky character, this is a handsome young wizard who conducts his magic on the side of light and good. Of course, he has no idea how much better darkness and evil pay. We're talking major bucks. Hold on, I think I hear his agent calling on my other line.

As to costume, note that on his belt he carries a pouch with all the ingredients necessary to cast bewitching spells. And the cape is more than just a fashion state-ment. It's what's called a *costume signal*. It's used to telegraph a message to the reader. Number one, it says that this is a charac-ter with special, magical abilities. And number two, it says that you should never allow your impala to select the color of its own cape.

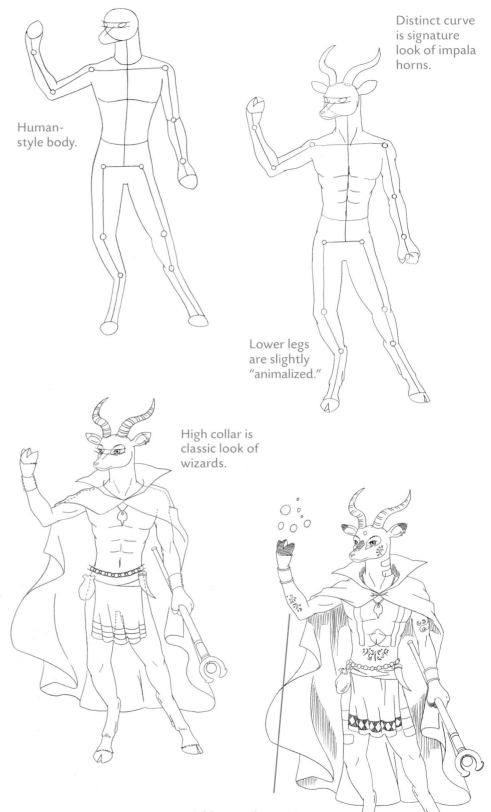

Human-style body.

Distinct curve is signature look of impala horns.

Lower legs are slightly "animalized."

High collar is classic look of wizards.

Add some decorative markings on body that look like occult symbols.

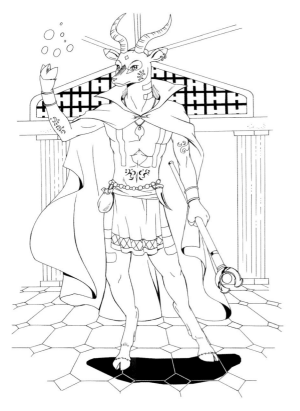

Framed by the two columns and centered in the archway, the character takes on more importance in the picture.

Note the height difference. When standing on two legs, the furry is much taller than an impala on all fours.

The fanciful markings are a different hue from the orange-brown color of the impala's natural coat. Don't change every color on him, as that would get too confusing. Better to keep the underlying color, the orange-brown, and just change the color of the markings.

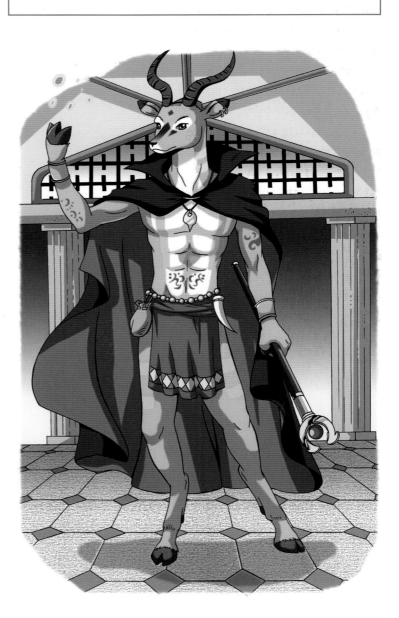

# WILDEBEEST WARLORD

The plains of Africa are a great place to explore furry characters. Yes, we love our foxes, wolves, coyotes, and the like, but when it comes down to creating something intense and different, it's time to hop continents to Africa. The wildebeest has a naturally darkened face, small eyes, and stripes. Plus, it has a very powerful build.

Most hoofed animals are sweet and charming and make you want to either pet them or milk them. Sometimes, they make you want a burger, but we try not to think about that. The wildebeest, however, is different. It has a darkly intimidating look that's usually associated only with homeroom teachers.

This furry is an extraordinarily strange-looking fellow. He's weird enough in his normal, four-legged stance, but when you sit him upright, like a human, he's utterly bizarre. But that's good—for villains, that is. We want our bad guys to creep us out so that we fear them. After all, there has never been an effective *cute* warlord.

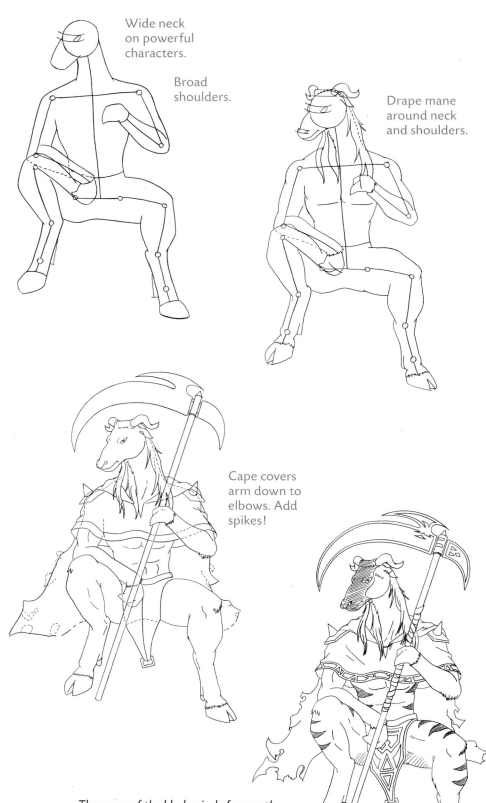

Wide neck on powerful characters.

Broad shoulders.

Drape mane around neck and shoulders.

Cape covers arm down to elbows. Add spikes!

*The curve of the blade nicely frames the head, but leave enough room under that blade for the character, otherwise it will appear claustrophobic.*

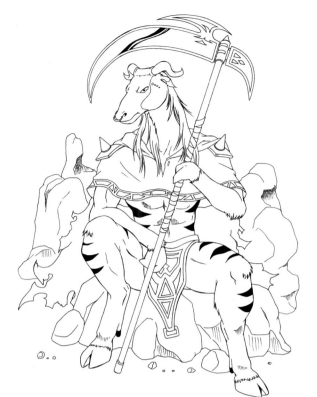

Although his body is in a total front view, his head turns to one side. This is preferable to having the head also looking straight forward, because then the entire character would flatten out. This way, we get a clearer view of him.

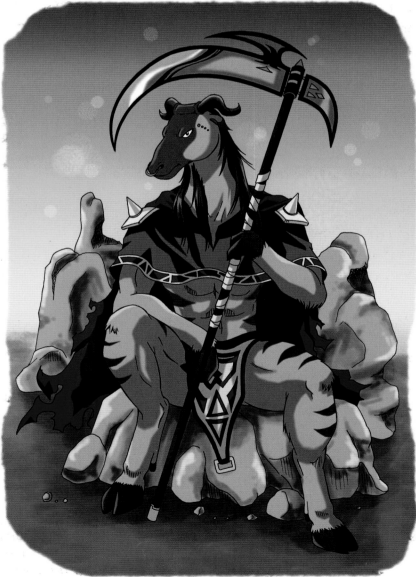

The warlord has been placed against the backdrop of rocks and an angry red sky. This unforgiving background is not soft and lush, like a patch of tall grasses and a blue horizon. This helps to underline the villainy of the character.

## chapter 8

# Occult & Magic Furries

Past the dark mountains, past the point where all trails end and the air is so thick it blots out the sun, lies the Kingdom of Occult and Magic. From all over they come, to the temples and towering castles—the furry band of warriors, wizards, and vagabonds. Some fight for good; others fight for the dark side of the soul. It is a war without end, and you, my artist friend, are the key to victory. Are you ready to draw these characters of the dark arts in their most magical poses?

# COUGAR DARK WIZARD

There are many heavyweight characters in the occult and magic genre, but the granddaddy of them all is the furry wizard. The original legend of King Arthur, as written by Sir Thomas Malory, calls for Merlin to be half man, half devil, so you know he's not just some magician guy who makes ladies disappear in a box or something equally yawn inspiring.

And if human Merlin can have a mysterious beard, then cougar Merlin has gotta have one, too. A furry wizard is every bit as eerie as a human wizard, maybe even more so. Look at those cat-eye pupils. Talk about all-seeing. And those clawlike fingernails, fixed up with occult rings. Boo! Am I scaring you yet? How about an amulet around the neck? A big, chunky jewel. Because we're talking major spells. Turn-you-into-a-frog-and-make-you-cry spells.

Now, the Merlin robe is sort of an official uniform. If you draw it, you have to agree to certain rules: You have to always draw long, billowing sleeves. It's mandatory. I once tried to draw a small-sleeved Merlin. Got a ticket in the mail the next day for fifty bucks. So you want to avoid that. The trim should be decorated with moons, stars, planets, and suns. Last, he has to have a wand to go with it. If it's not a wand, a staff is just as good, but it has to look craggy, like it was left in the ocean for months. Now that's a wizard!

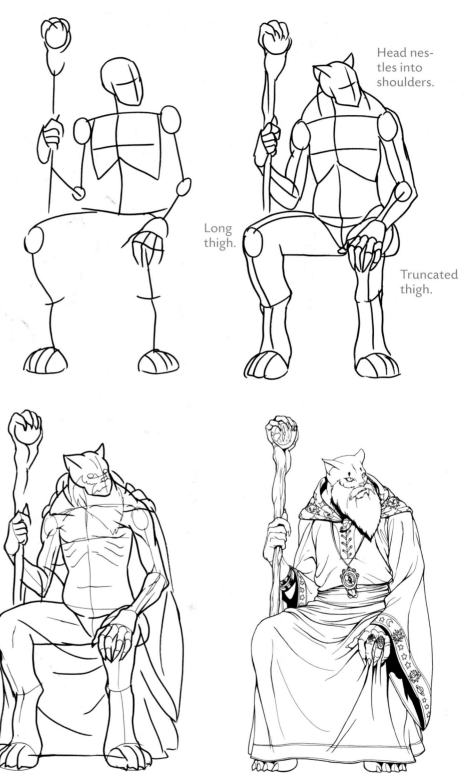

*Due to the effects of perspective and foreshortening, one thigh (seen from the side) looks long, while the other (in a near-front view) looks very short and truncated. The head is lowered into the frame of the shoulders, making him appear hunched over and therefore older, like a wizard.*

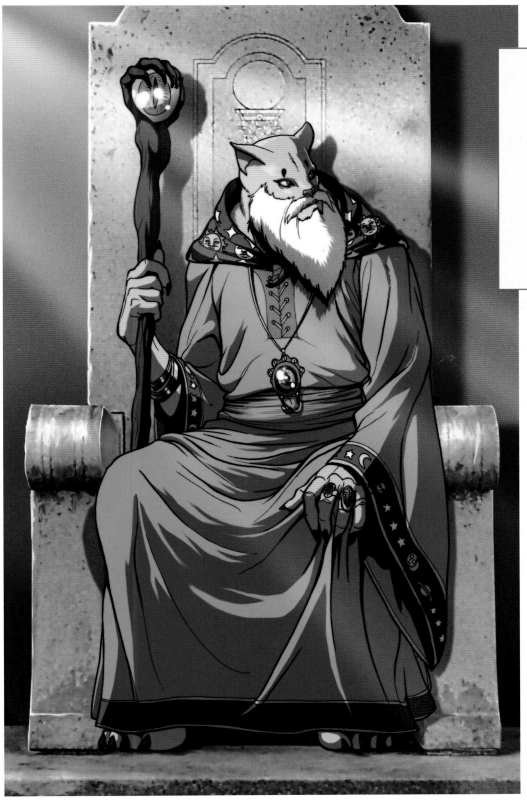

Here's another design element that makes this character unique: He's got a mixture of four different surface textures, each one old and creaky. First, there's his aging flesh and bones (see his hands), then his scratchy beard, next his wrinkled robe, and, finally, his knotty wooden staff.

*If you look closely at the face, it looks difficult to draw. It's easy to see how a beginner could get lost trying to copy it. Half the face is buried under a mound of beard. So, simplify it; you have enough knowledge about the underlying head structure to extrapolate all the needed information from the visual clues here. And even though the beard will ultimately hide half the face, still start out by sketching in the entire construction of the head.*

# WOLF KNIGHT

Who needs werewolves when you can have a wolf in full knight's regalia? This is another good character type for furries—and one that's more literary, as it's a motif used in books and graphic novels. As popular legends go, this furry was once a human knight who fell victim to the spell of an evil witch. The knight must now live in this accursed form. He is repulsive to the woman he once loved. He is shunned by the people he once called friends. He wanders through the dark side of the forest, battling demons while searching for the one who can set him free. That type of story turns what would otherwise appear to be a villain into a tragic hero—and a very sympathetic character.

Sword at an angle.

*Holding the sword at an angle is more dramatic than holding it vertically or horizontally.*

Open palm clutches at air for a poetic hand expression.

Outstretched leg for an expressive pose.

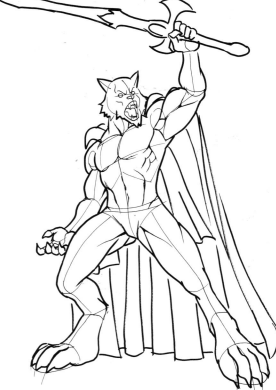

*An elaborate chest plate is gothic.*

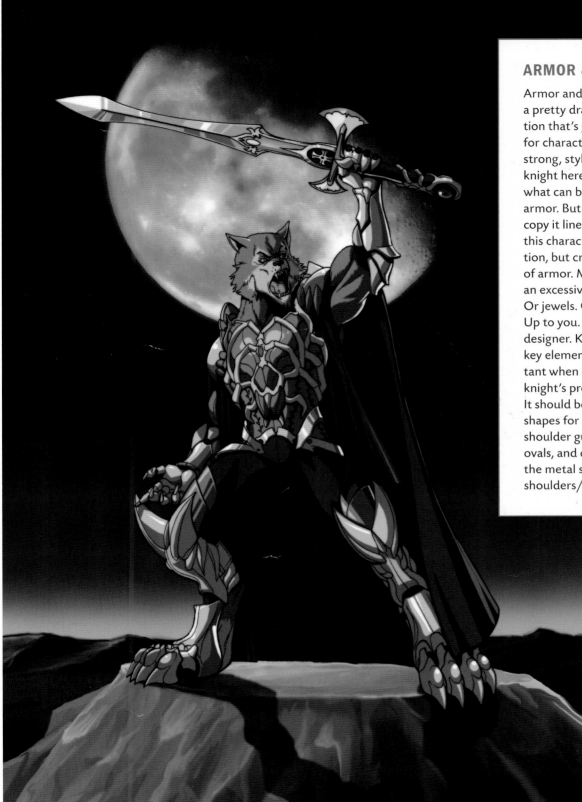

## ARMOR & CAPES

Armor and capes make for a pretty dramatic combination that's generally reserved for characters who are bold, strong, stylish leaders. The wolf knight here is an example of what can be accomplished with armor. But you don't have to copy it line for line. Instead, use this character as your foundation, but create your own style of armor. Maybe yours will have an excessive amount of spikes. Or jewels. Or animal symbols. Up to you. You're the creator/ designer. Keep in mind these key elements that are important when designing a dashing knight's protective body armor: It should be layered. Common shapes for knee, hip, elbow, and shoulder guards are diamonds, ovals, and circles. And most of the metal should appear on the shoulders/chest/rib cage area.

# ELK SWORDFIGHTER

The trick is to give this gal furry fighting armor but to make it look like it was manufactured by a high-end Italian clothing designer. To make her look her best, the armor must leave major areas of her body exposed and vulnerable, otherwise she'd look like a fire-plug inside one of those tin suits. The more of her body we see, the better she'll look. The armor becomes an impression of a costume rather than a real costume. On that note, instead of drawing armor on her arms and legs, try drawing body-fitting gloves and boots first and *then* decorating them to look like armor. They'll look better if you approach them from that angle.

Now look at the pose. It's telegraphing its meaning: It reads as *sturdy*. How does it accomplish this? When the feet are far apart, the center of gravity is lower to the ground, and the character exudes a feeling of strength. In addition, the sword is held straight up, in front of her face, which signals that she's on high alert, keeping her eyes focused on the enemy ahead of her.

Both hands planted on hip.

Foot under head is center of balance.

Antlers sprout multiple horn tips.

*The origins of the antlers are covered up by two sections of bangs. This frees you up from having to draw the antlers affixed into the actual skull, which could look—ouch!—painful.*

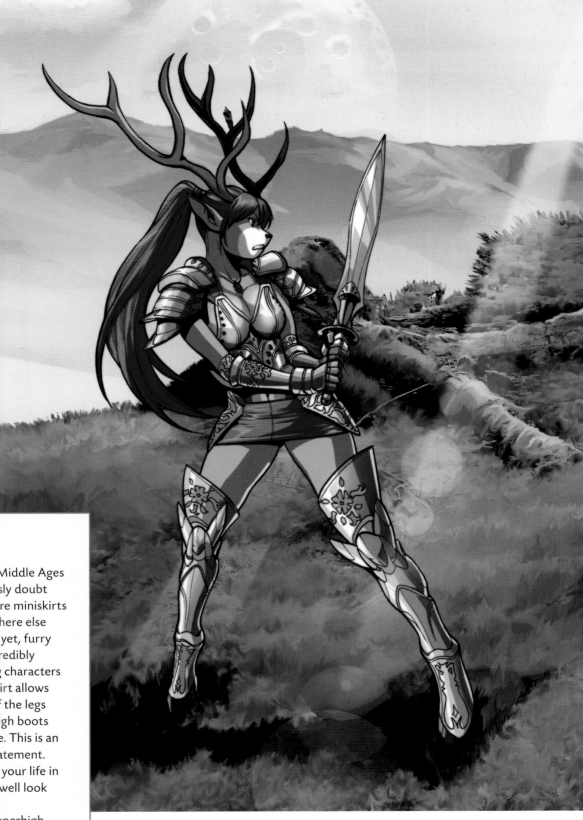

## BOOTS

My research on the Middle Ages has led me to seriously doubt that knights ever wore miniskirts into battle—or anywhere else for that matter. And yet, furry artists find them incredibly useful when drawing characters in armor. The miniskirt allows you to show some of the legs between the knee-high boots and the skirt hemline. This is an appealing fashion statement. Hey, if you must risk your life in battle, you might as well look good doing it.

In addition, the superhigh boots are drawn to mimic leggings, which were also a rarity in medieval times.

# COLLIE WARLOCK

Whether by himself or in a group, the furry warlock has a library of spells and incantations for every whim and want. A potion for this and a potion for that. But he exacts a price for every little favor he bestows on his visitors.

The warlock has bony, slightly hunched shoulders. The hat is a classic shape—an upside-down cone with a brim. The cloak is torn, more rag than clothing. The hair looks as though it hasn't seen a scissors in years. To complete the wardrobe, give him a cape . . . not that he needs it, but after all, it is part of the official warlock uniform, as stated in the booklet *Uniform Code of Witches and Warlocks*, Section II, subparagraph C, under Attire.

The other essential item? The cauldron. Soup's on! This brew isn't going to be clam chowder, split pea, or minestrone anytime soon. This strangely colored concoction is so disgusting that it could only come out of a witch's or warlock's cauldron—or a high school cafeteria.

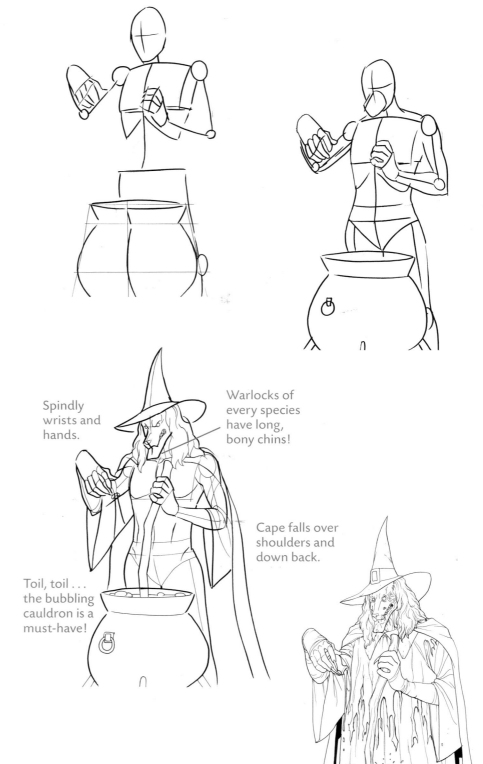

Spindly wrists and hands.

Warlocks of every species have long, bony chins!

Cape falls over shoulders and down back.

Toil, toil . . . the bubbling cauldron is a must-have!

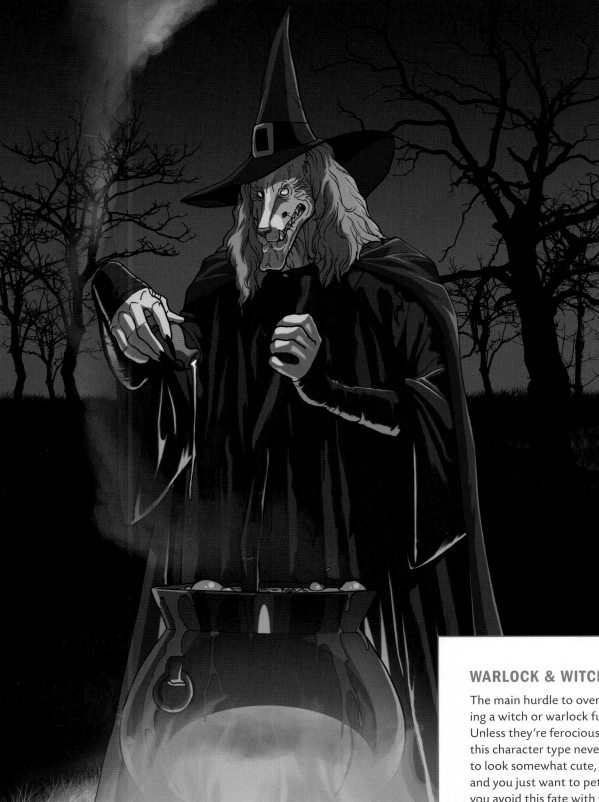

## WARLOCK & WITCH EYES

The main hurdle to overcome in designing a witch or warlock furry is this: Unless they're ferocious (something this character type never is), they tend to look somewhat cute, as all furries do, and you just want to pet them. How can you avoid this fate with your witch or warlock? It's easy: "Blank out" the eyes. Remove the pupils and irises. That produces an otherworldly, sinister appearance. Not so cuddly anymore, eh?

# RACCOON VAGABOND

He's a troubadour with a mandolin but without much money. But oh, does he have style. He can serenade all the fair maidens in town—until the knights come back, that is, and then he's got to scram if he wants to hold on to his hide. He's a small-time scam artist who survives by his wits alone. Yes, he's a bit of a rogue and a thief, but look who he steals from! All bad guys.

Even though he has broad shoulders, draw him skinny, as if he has been forced to skip some meals while on the run. And remember the accoutrements he wears: earring, necklace, bandanas, and bracelets.

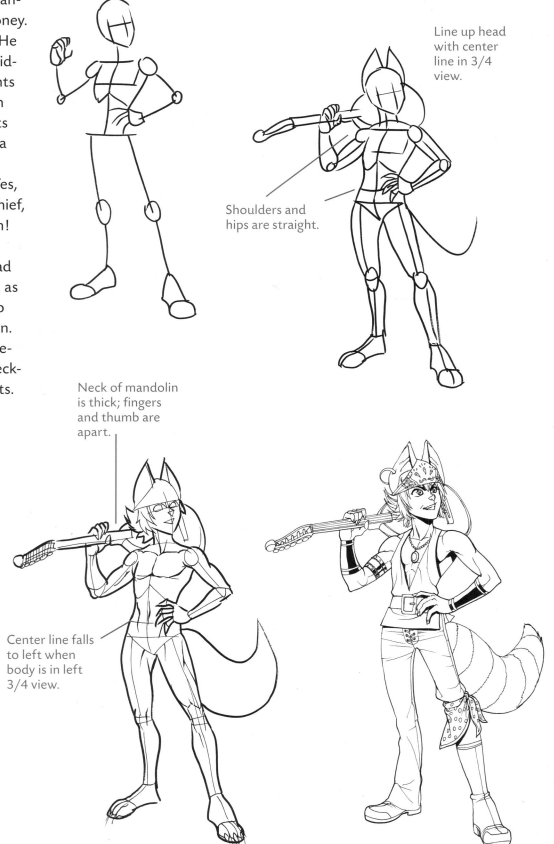

Line up head with center line in 3/4 view.

Shoulders and hips are straight.

Neck of mandolin is thick; fingers and thumb are apart.

Center line falls to left when body is in left 3/4 view.

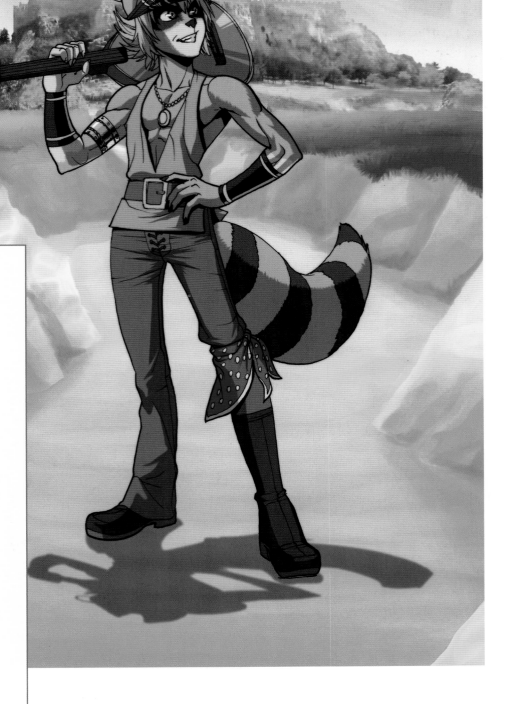

## MUSIC

The days of old were a nobler time. It was a time of chivalry and of heroism. It was a time of bravery . . . and of belching at the dinner table and being bled by the barber when you had a head cold. Ah yes, what a noble era it was.

Music was also an important part of the culture. The instruments back then differed in look from those of today. As artists, you have to make that distinction when drawing characters of an older age. The most popular instrument back then was the lute, of which the mandolin was a variation. Next was the flute or recorder. The most visually interesting flute is the pan flute, which is the multilayered flute often seen played (in paintings) by Pan, the half-goat furry (the Greek god of nature).

You can do a Google search for "medieval instruments" to come up with many interesting images. For example, there were wind instruments made out of animal horns as well as handheld harps.

# PANTHER VAMPIRE

Personally, I'm not scared of vampires. Nonetheless, I'd let this guy cut ahead of me in line anytime he wants. Hey, my lunch money is his lunch money, if you know what I mean. Even Dracula doesn't have bicuspids that large and pointy. And to think, a little orthodontic care would've fixed all that as a child. Now we turn to his costume. It's so tight that it shows every muscle of his torso and arms. That's a dramatic method of drawing costumes. The outfit is also so "Lucifer": flashy but very, very evil. Look at how much shadow is applied to it, all to further create that look of darkness. Note the severe, ultrahigh collar, which you only find on bad guys. Someday I gotta have a good guy explain to me why that is.

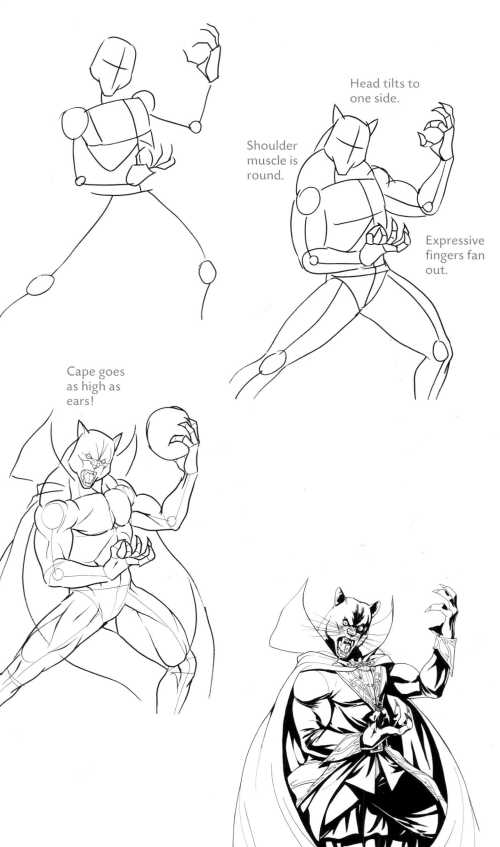

Head tilts to one side.

Shoulder muscle is round.

Expressive fingers fan out.

Cape goes as high as ears!

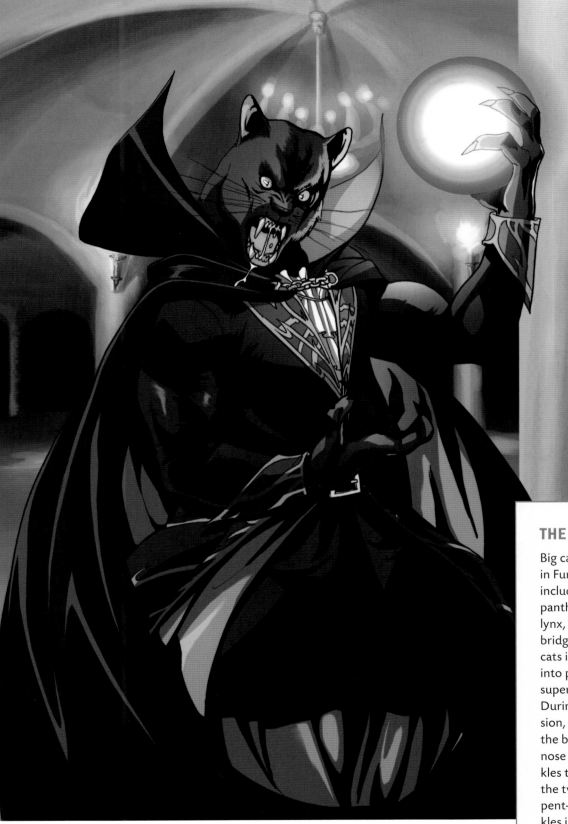

## THE MUZZLE

Big cats are popular in Furryland, and they include lions, tigers, panthers, cougars, and lynx, among others. The bridge of the nose on big cats is wide, and it comes into play when drawing superintense expressions. During an intense expression, such as you see here, the bridge of the cat's nose gathers up into wrinkles that appear between the two eyes, creating pent-up force. The wrinkles involve the eyebrows as well as the bridge of the nose and continue down to the nose itself.

# BULL DEMON

This demon is a colossus who has snatched up several poor, furry souls who have wandered haplessly into his domain. Steaming with fury, this horned creature of darkness is cast as the demon guardian over a small, helpless village of furries. Now the bad news: He's the guy your puny furry hero character has to fight so that he can rescue the girl, so that the village will be saved, so that everyone can live happily ever after. Or maybe your good guy could just date some other girl and forget about fighting this dude. I'd vote for that.

Giants should look gigantic—and not just due to the comparative scale at which they're drawn (i.e., a giant standing next to a tiny person). The giant must also have giant features and proportions or it will seem as though you've taken a human character and enlarged it, nothing more. So here, the head is very small compared to the size of the body. The smaller the head is compared to the body, the taller the character will appear to be, as a general rule. At the same time, the lower legs seem to distort and come toward us, increasing in size so that the feet, or hooves, look gigantic. That, too, creates the illusion of immensity.

Once you've built a giant-looking foundation, you can go ahead and add props, drawn to scale. Draw some smaller-looking, captured furries in his clutches. Now he looks like one giant, ticked-off furry because of all the elements added in support of the idea.

Tiny furries make him look immense by comparison.

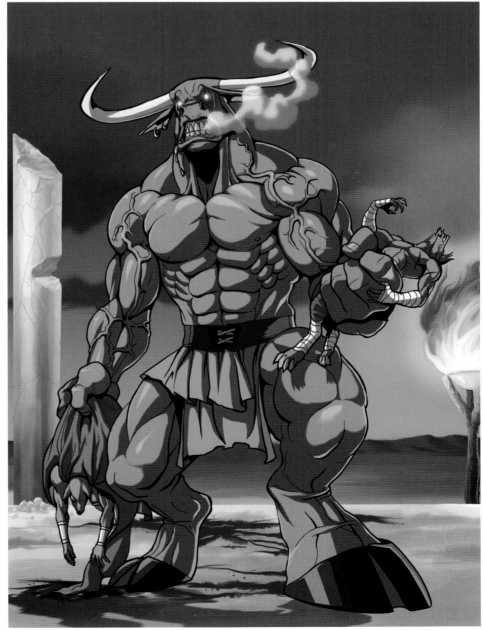

# BRAVE CATTLE FIGHTERS

Into the darkest corners of the land, the bravest of hearts must go. Characters like these are often on a quest, not out of choice but because they have *been chosen*. They're the only ones who can make the journey. They're outnumbered and overmatched—in everything but spirit and determination! Can they survive the perils they will encounter, the obstacles that will surely stand in their way, as they climb and claw their way to their destination and ultimate fate?

We'll never know, because we don't have time to finish the story. We're gonna learn how to draw it first! This is the classic "We're surrounded!" pose. The two characters typically back up to each other until they're literally back to back. Each holds a weapon in front of the body vertically (remember, holding a weapon vertically before your face means you're on high alert). It's a reflexive action, whereby the figure holding the weapon uses it like a shield.

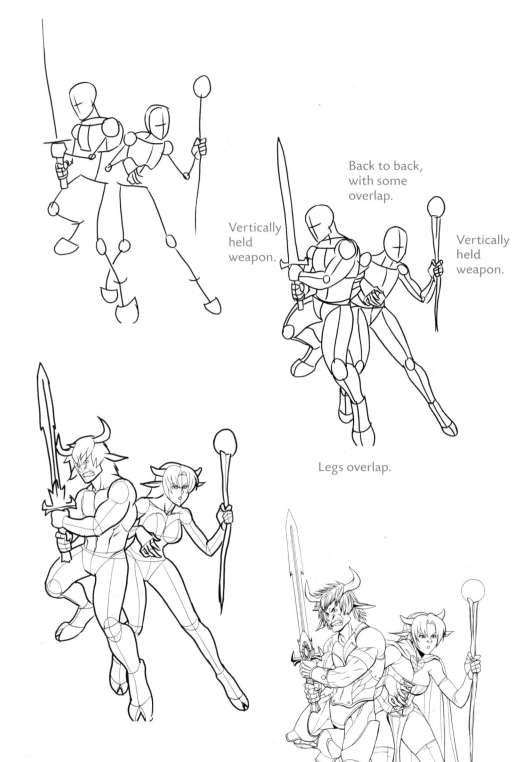

Back to back, with some overlap.

Vertically held weapon.

Vertically held weapon.

Legs overlap.

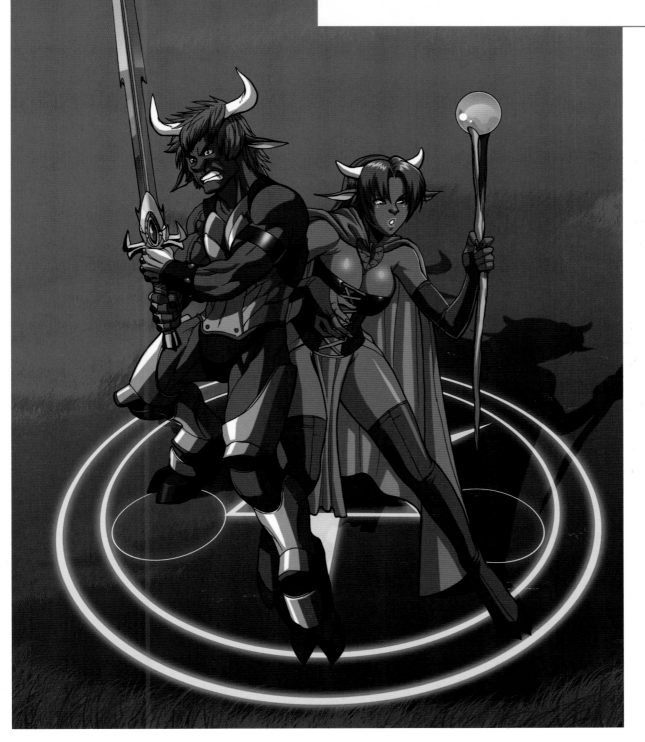

## ANGLES

We talked a little about angles on page 36, but mainly, we've been drawing the figures straight on, at a neutral angle. This scene, however, begs for special treatment. Since these fighters are seriously outmatched, they've been purposely drawn from a high angle, meaning we're looking at them from slightly overhead. This "down shot," as it's sometimes called, makes them look weaker and more isolated. The result is that they're more sympathetic characters to the reader.

# LONE ELF WARRIOR

How many times have you seen an elfin girl on horseback with a sword? Ho-hum. You wanna see her again, or do you want to wake up your readers with something new and adventurous? You're in a fantasy world, pal. You've got the pencil in your hand. That thing's as good as a darn wand, for cryin' out loud. You can do anything you want with it! Draw her on the back of a lion, a bear, a cyclops—whatever springs to your mind. Just make it new and innovative, and go with it. These are your creations. You don't have to copy what you've seen in a movie. Be inspired, but be creative. Be the boss. Think outside of the hexagon.

Here's a good place to get started: a gorilla for transportation. You don't see that very often. Let's give this one a try, shall we? Our lone warrior is riding on the back of her biggest weapon. The gorilla is huge, with an enormous forehead and massive shoulders. It runs on its fore-knuckles, which sounds like a bad idea to me, but then, no one asked me. That pronounced hump on his back overlaps the warrior somewhat, giving her a good riding position.

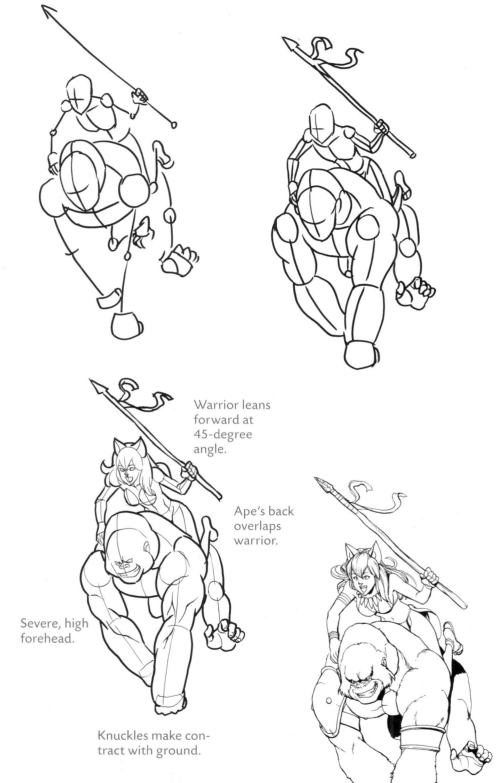

Warrior leans forward at 45-degree angle.

Ape's back overlaps warrior.

Severe, high forehead.

Knuckles make contract with ground.

It's true in sports, and it's true in drawing any and all types of action poses: Your characters should *lean into the action* of a pose, not away from it. So a rider galloping forward on an ape should lean forward in the direction that the ape is moving. Notice how much more exciting the image becomes. If the ape is bent over and galloping forward, bend him down even farther and he, too, will look swifter and more aggressive.

# chapter 9

# Furry Family Fun

Meet the Furnworths! They're Greenwood Meadow's favorite furry family. Greenwood Meadow is Anyplace, USA. Wherever there's a field, behind a giant strip mall, you'll find this furry family: mom, dad, older sis, little brother, big brother, and the neighbor from the tree next door. It's good, wholesome furry fun for the entire family. They're here for a little zaniness and some laughs along the way. With these character types, furries can be drawn more at the cartoon end of the style spectrum. Still, they're not typical cartoon animals. They're anthros. Hybrids. They've still got that human look to their clothing, posture, hair, and features.

# MANDY (THE GIRL NEXT DOOR)

She's the pretty, sweet one whom Chester, the big brother in the family, has a crush on in school. Chester always asks her for help with his homework so that he can see her. But she's convinced Chester doesn't like her and is only interested in her for her homework assignments.

To keep her cute, draw both her mouth and nose tiny. Her eyes should be spaced far apart, which is a sign of youthful innocence. She has short arms and legs and a harmless amount of pudginess to her tummy. Her back arches, pushing the tummy outward just a little, which creates a cute pose. And she wears school clothes: a knockabout skirt, some capri pants, and slip-on shoes. Notice how the color of the book ties in nicely to the color of her hair.

Just what kind of animal is this furry, exactly? She's part squirrel, part hedgehog, part beaver, and part gopher. And the rest is made up! When you're designing each furry in a cast of characters, it's not important that your reader be able to identify the precise species; what's important is that the cast of characters in the *same family* all look as though they're small woodland creatures.

Spine arches.

Calf bones arch in.

Short hair.

Small muzzle and mouth.

Draw backpack after body is in place.

## VARIETY: THE KEY TO DESIGNING A GROUP

When creating a cast of furry characters, you want to come up with a good mix.
Take a look at the players here, all different from one another. Style note: We've
made them retro, which shows just how flexible the furry genre can be.

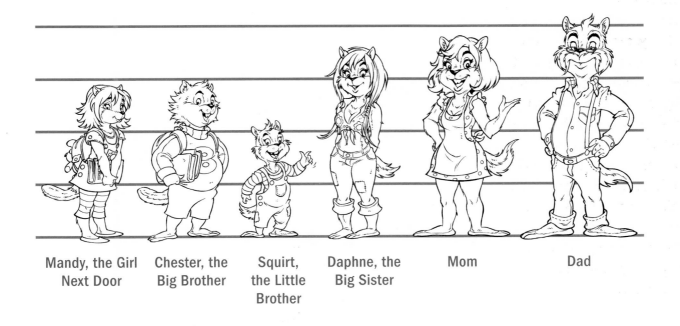

Mandy, the Girl
Next Door

Chester, the
Big Brother

Squirt,
the Little
Brother

Daphne, the
Big Sister

Mom

Dad

# CHESTER (THE BIG BROTHER)

Here's a good example of a walk drawn in a 3/4 view. Notice how the front foot is leading with the heel, and the back foot is pushing off on the toes. Both knees are bent, because he's in midstride. A bit on the chubby side, his torso takes the shape of an eggplant. A shirt and shorts are a good combination for an active kid. But leave off the shoes. I know that sneakers seem like a fun addition, but you'd be painting yourself into a corner by covering up all signs of his animal nature. *You need the furry feet.* They're important to help create his identity. How could they possibly fit into sneakers anyway? They're way too long.

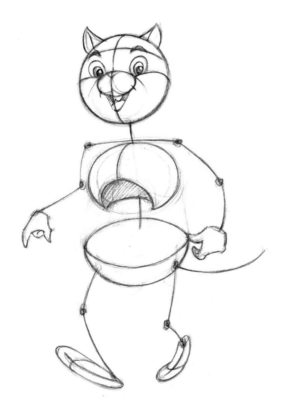

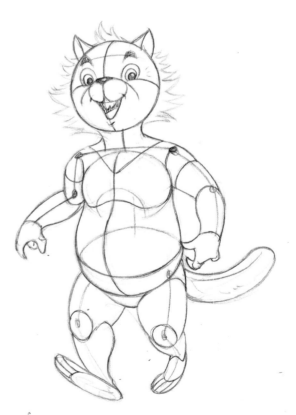

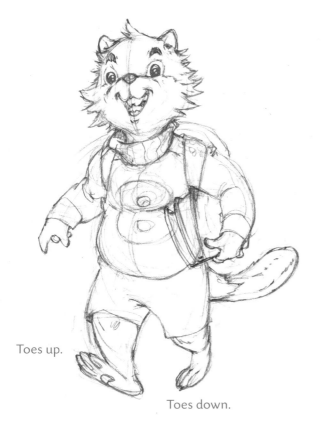

Toes up.

Toes down.

## TWO-TONED FUR

The two-toned fur coloring of the face is a look that has its roots in animated cartoons of animals. This feature can also be effective on furries. It brings out the charm in an expression. It's not recommended, however, for villains, as it tends to soften the look of a character by focusing the reader's attention on the eyes, which are encircled by the second tone. It also emphasizes the cheek area of the face with a second tone. Those chubby, pudgy cheeks make this guy look like a squeezable plush doll. Don't give him any chin. As a rule, cute characters—of any species—have small or nonexistent chins.

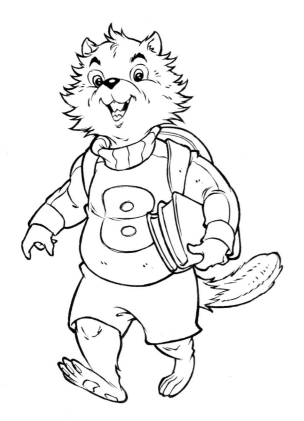

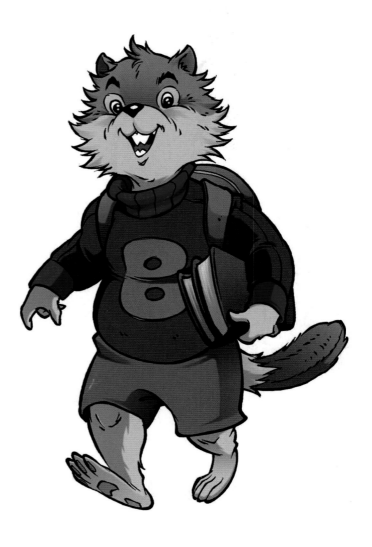

# SQUIRT (THE LITTLE BROTHER)

I suppose this little fella could be the walking definition of *bright eyed and bushy tailed*. A tilt of the head, a bounce to the walk, arms out to the side and you've got an irresistibly cute character. Here's where a couple of buckteeth make a huge difference in the character design. Buckteeth are often misunderstood, and it's assumed they make a character look goofy, when in fact they are most often used to highlight a character's youth and innocence. Look how well they complement those bushy cheeks. And to top off that youthful expression, his large pupils are slightly—just slightly—cross-eyed. It creates a sweet smile.

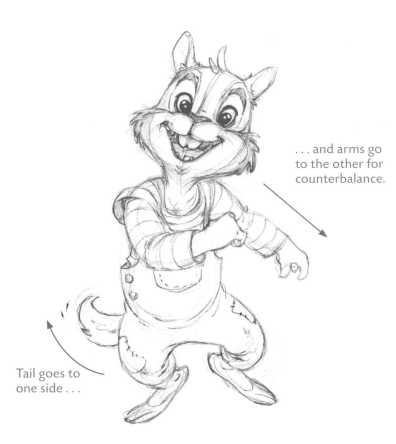

. . . and arms go to the other for counterbalance.

Tail goes to one side . . .

## WALKING

A walk seen from the front, as in this pose, is actually one of the more difficult actions to draw, thanks to the angle. The perspective flattens out so that neither leg looks like it's out in front of the other. Therefore, most of the action is left to the arms. And with those arms, you can really go to town, swinging them all the way to one side, then across the body to the other. That'll really create the illusion of motion. The tail should appear on the opposite side of the body as the arms, as a counterbalancing force.

# DAPHNE (THE OLDER SISTER)

When you have a fun-loving character, you need to come up with a fun pose to communicate her personality to the reader. Are you going to let the face do all the work in creating the attitude? That's some heavy lifting. What do you say we get the body into the act, too? Beginners rely mainly on the facial expression. More experienced artists use the body language as an equal partner in communicating emotions. In this case, both the face and body are supporting each other in communicating one idea: playfulness.

So let's look at the body language. What makes this pose read as playful? First, the knees and feet are turned inward in a childlike way, which reads as silly and just plain fun. The torso is leaning forward in a teasing gesture. And the finger on the cheek is meant to be coy. This is one furry on cute over-drive! And when you examine the expression, you'll notice that her eyeballs are resting on her cheeks, which is an effective way to communicate a look of charm.

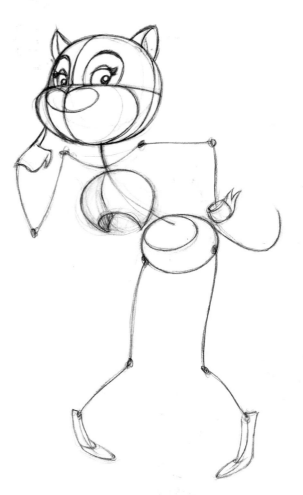

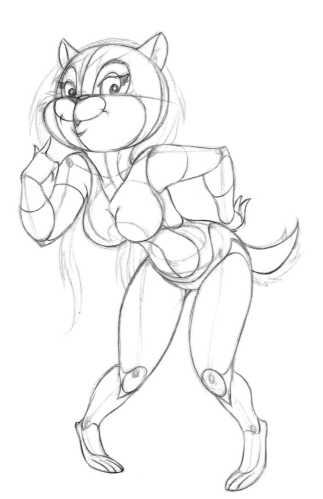

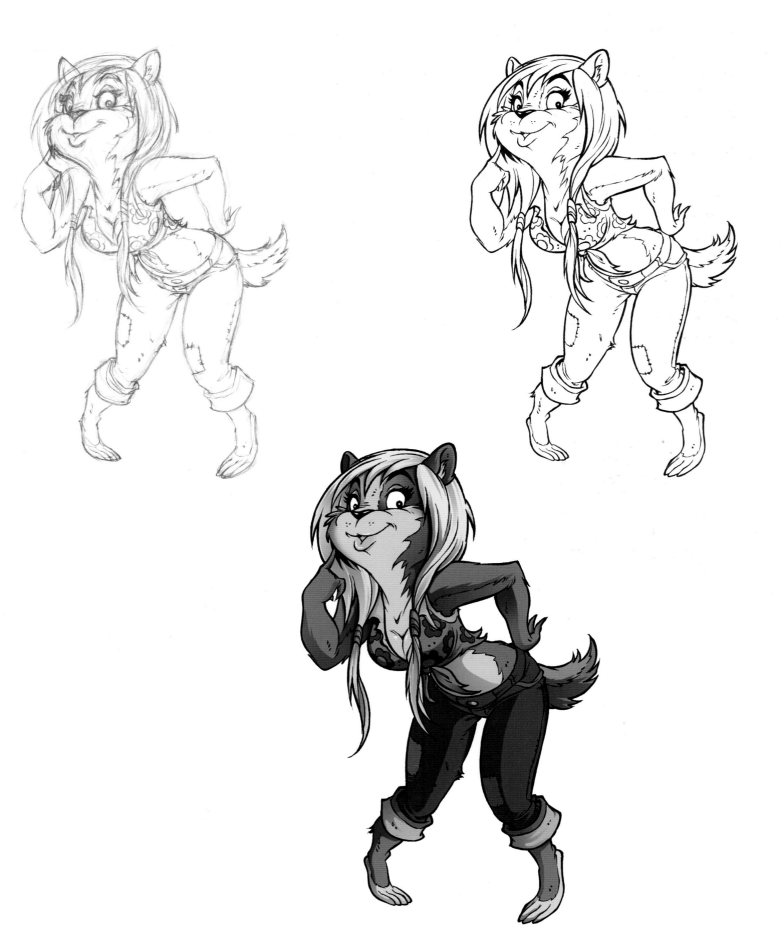

# MOM

Home "fur" the holidays. Here's the busiest homemaker in the woodlands. The little lady who puts the acorns on the table, piping hot. Mmm, mmm. As we age, we put on a little bit of poundage in the caboose, so mom's going to widen out a bit in the hip department. Draw the arms and legs together to give her a feminine, tidy appearance—a little toward the OCD side of the spectrum.

No buckteeth for mom or dad, because buckteeth signify youth. Mom has proper-sized teeth. And we're going to be as politically incorrect as possible and stick an apron on her and make her happy about it; yes, she actually likes being in the kitchen day after day. But we should also make her a little kooky and bring out the compulsive side of her perfectionism. So she should always be offering food, every few minutes. First it's only fruit, then nuts, then brownies, cookies, pasta, beans, lobster, cactus, breaded larva . . . just get random!

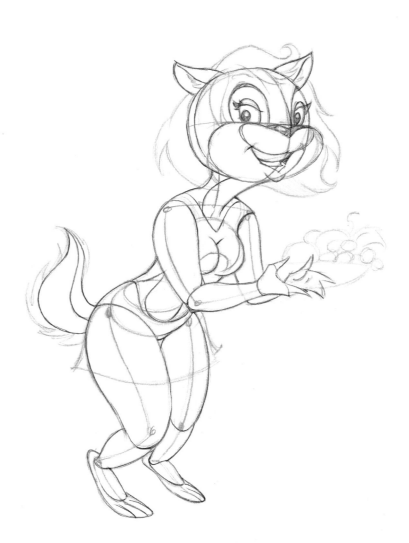

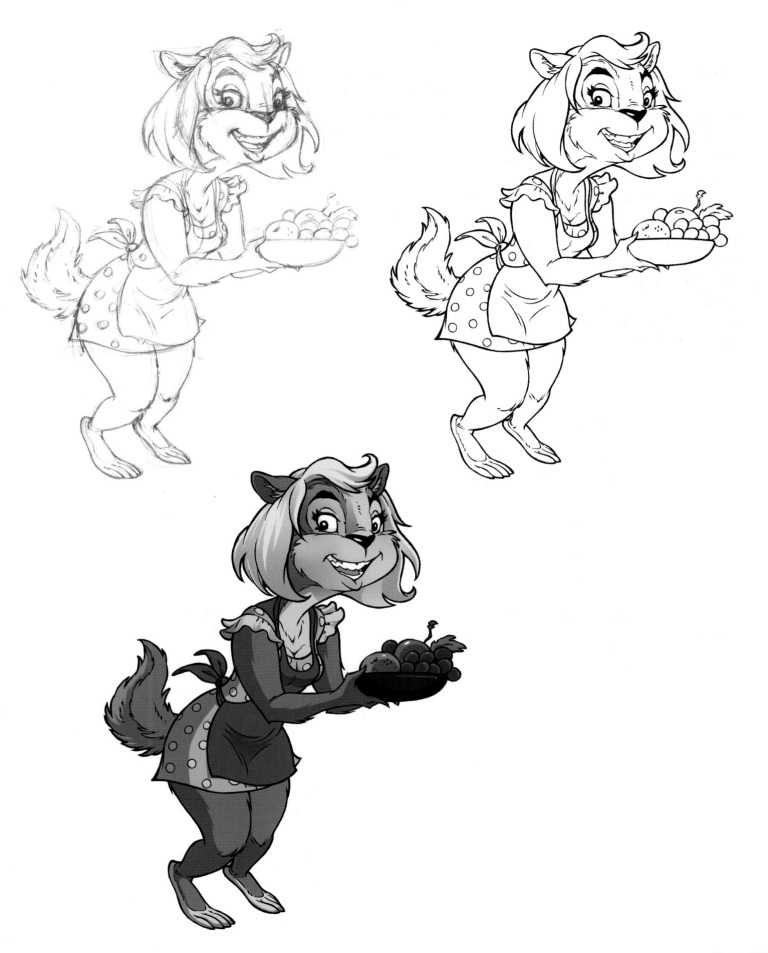

# DAD

He's the proud father of the furry family. It's important to figure out how to show his age. Height is one element. Add eyeglasses or spectacles and a mustache—but not a beard. Grandpa furries get beards. Also, Dad grows a paunch, and the chest sinks in a bit. Sorry dads, but you know it's true. Give him the dad uniform: suspenders. What a fashion statement that is. You've got to carbon-date a department store catalogue to find the last time suspenders were in fashion. The patches on his clothes show that they're handmade from stuff that's "borrowed" from backyards. Furries are resourceful little critters.

Notice that the mustache doubles as the upper lip in creating the smile. The eyebrows are big and bushy, another sign of age but something that is also very useful for expressions and humor. Spectacles, like these, are drawn with very thin frames, because they overlap the pupils and would otherwise obliterate the eyes if the frames were thick.

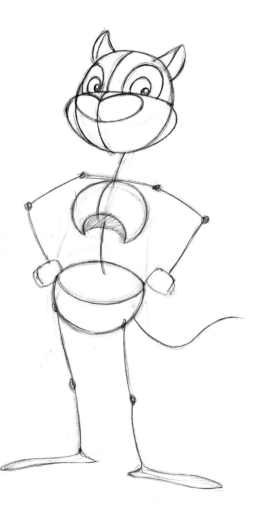
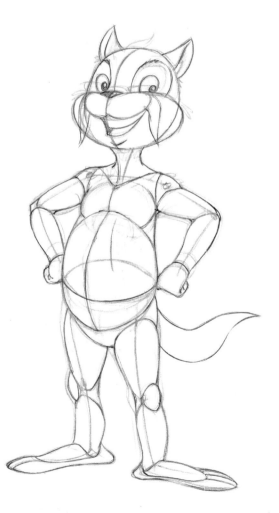

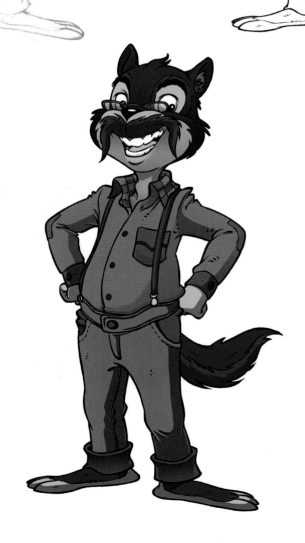

## THE 3/4 VIEW

Here we have a character standing in the classic 3/4 view, with arms akimbo. The 3/4 view is a pleasing one in which to portray a character. The reader generally finds it so. From this angle, the character looks proud of himself, happy. But if he had his arms akimbo in a front view, he might look defiant or impatient. So in addition to the look on a character's face or the pose, it's important to consider the angle when you choose an expression. Remember to use the 3/4 view when showing off the most appealing expression of a character.

# TEEN COUPLES

When you're drawing two or more characters together, especially couples, you have to show them somehow relating to each other in the scene, otherwise you'll fall prey to the dreaded artist's trap: *two people unrelating*! What do I mean by "unrelating"? That means they're both in the same scene, together, without any interaction, as if they're strangers just occupying the same space, renting the same area. Don't want that.

## Splishin' and Splashin'

Okay, there's some action in this scene. But if you're not careful, they're gonna look like they're running a race against each other, which isn't the way a date should go. One surefire way to turn *unrelating* characters into *relating* ones is to make their body language mirror each other. The poses here are identical, with their strides moving in sync. And, of course, they're also holding hands. But more important is the shared *eye contact*. That's three elements altogether. You want a fourth? Okay. Their free hands are held up in the air, mirroring each other. Didn't think I could come up with a fourth one, did you? Never doubt the possibilities in the land of furry fantasies.

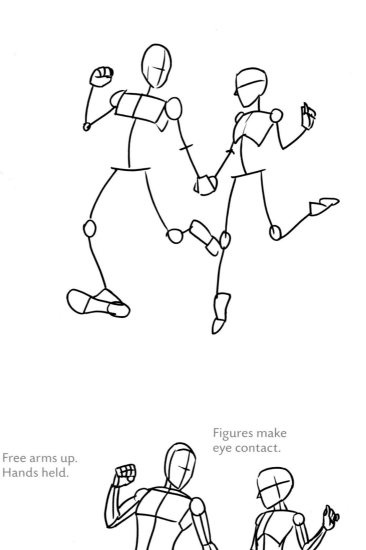

Free arms up. Hands held.

Figures make eye contact.

Right legs out in front, in tandem.

Left legs back, in tandem.

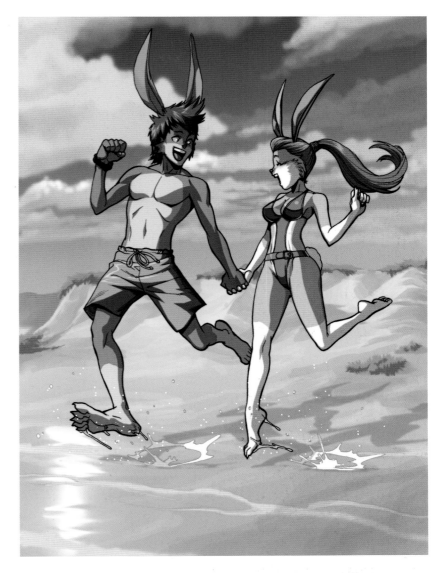

## At the Amusement Park

An amusement park is always a good place to stage a scene for teens. Lots of action, not too much perspective to worry about, just rides such as a Ferris wheel or roller coaster in the background. But you don't even need a background. Once you draw that big serving of cotton candy and two teenagers on a date, we know exactly where we are.

Again, there's the challenge of two characters *unrelating* in a scene. But one thing pulls them together here. Can you tell what it is? It's each character's line of vision. As a reader, your eyes follow the gal's line of vision to the cotton candy. From the cotton candy, your eyes travel to the guy's face. He looks at her, so your eyes go back down to her face, creating a never-ending loop. It keeps you involved in the picture. You have no mind of your own. You must keep looking at the pretty scene. Mwa-ha-ha-ha! Um, sorry.

In addition, there's one more thing that binds the couple together, and it's simply this: Her head overlaps his shoulder in the picture. That's called a *tangent* (where they touch), and it causes them to meld, visually, into a unit so that we no longer see them as individuals but as a couple. Brilliantly diabolical, don't you agree?

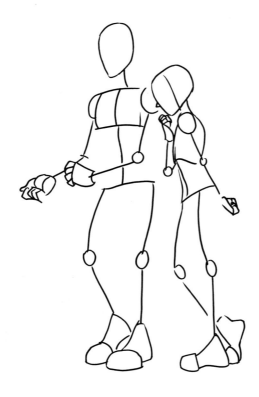

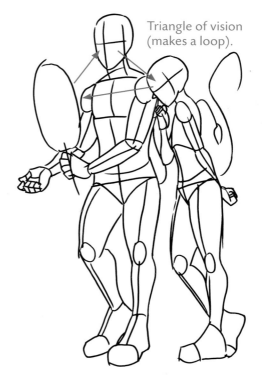

Triangle of vision (makes a loop).

Head overlaps shoulder, creating a tangent.

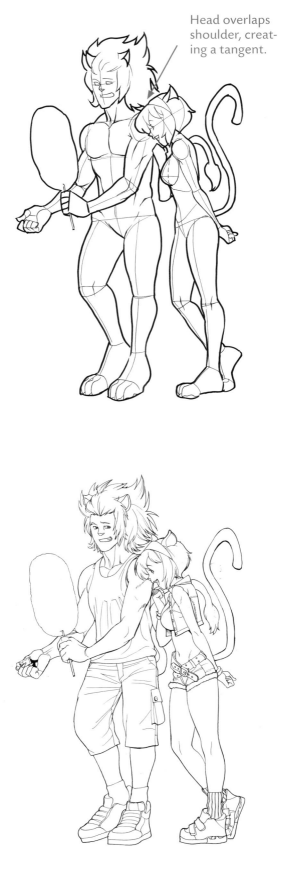

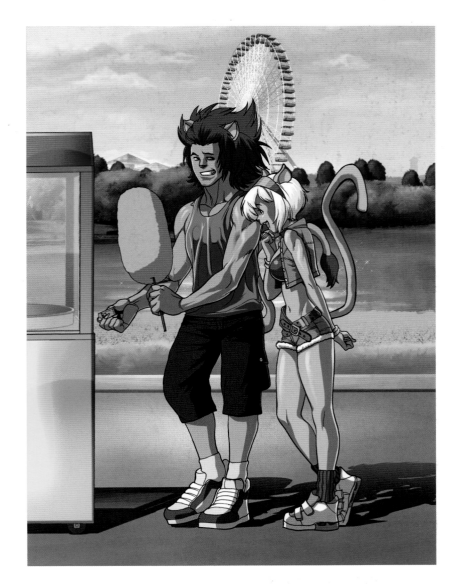

# INDEX